AFROTOPIA

A Univocal Book

DREW BURK, CONSULTING EDITOR

Univocal Publishing was founded by Jason Wagner and Drew Burk as an independent publishing house specializing in artisanal editions and translations of texts spanning the areas of cultural theory, media archeology, continental philosophy, aesthetics, anthropology, and more. In May 2017, Univocal ceased operations as an independent publishing house and became a series with its publishing partner the University of Minnesota Press.

Univocal authors include:

Miguel Abensour	Sylvère Lotringer
Judith Balso	Jean Malaurie
Jean Baudrillard	Michael Marder
Philippe Beck	Serge Margel
Simon Critchley	Quentin Meillassoux
Fernand Deligny	Friedrich Nietzsche
Jacques Derrida	Peter Pál Pelbart
Vinciane Despret	Jacques Rancière
Georges Didi-Huberman	Lionel Ruffel
Jean Epstein	Felwine Sarr
Vilém Flusser	Michel Serres
Barbara Glowczewski	Gilbert Simondon
Évelyne Grossman	Étienne Souriau
Félix Guattari	Isabelle Stengers
David Lapoujade	Eugene Thacker
François Laruelle	Elisabeth von Samsonow
David Link	Siegfried Zielinski

AFROTOPIA

FELWINE SARR

Translated by Drew S. Burk
and Sarah Jones-Boardman

A Univocal Book

University of Minnesota Press
Minneapolis
London

This book received support from the Institut Français through its publication program.

This work received the French Voices Award for excellence in publication and translation. French Voices is a program created and funded by the French Embassy in the United States and FACE (French American Cultural Exchange). French Voices logo designed by Serge Bloch.

Originally published in French as *Afrotopia*, copyright Éditions Philippe Rey, 2016. Published by special arrangement with Éditions Philippe Rey, France, in conjunction with their duly appointed agents L'Autre agence and 2 Seas Literary Agency.

Published by the University of Minnesota Press
111 Third Avenue South, Suite 290
Minneapolis, MN 55401-2520
http://www.upress.umn.edu

ISBN 978-1-5179-0691-7

A Cataloging-in-Publication record for this book is available from the Library of Congress.

Printed in the United States of America on acid-free paper

The University of Minnesota is an equal-opportunity educator and employer.

26 25 24 23 22 21 20 10 9 8 7 6 5 4 3 2 1

For Dialo Diop, sycamore of the Sahel . . .

CONTENTS

Thinking Africa

Thinking the continent of Africa is an arduous task, enshrouded in a fog of treacherous clichés, stereotypes, and pseudo-certitudes. From the very first moments the newly independent African nations began to set out on their new adventure in the 1960s, the commonly accepted notion spouted by the afro-pessimists was that the continent was already heading in the wrong direction; Africa was a wailing monster whose final agonizing convulsions already proclaimed the approaching end. These dark omens of its becoming led to the same convulsive rhythms and crises that the continent had already experienced and lived through. At the height of the AIDS pandemic, soothsayers even predicted the pure and simple extinction of the entire population of the continent. In the end, that this so-called *haven of misery* ended up collapsing under the weight of a health crisis in no way ensures that the rest of humanity, all things being equal, would have come out on the other side any better. One shouldn't underestimate the enormous amount of symbolic violence inscribed and represented within the collective African imaginary in the form of some sort of failure, of some kind of lack or handicap, or even as a kind of human deficiency and congenital deformity. We mustn't forget the weight of this symbolic violence that was directed at hundreds of thousands of people via media outlets and numerous literary narratives.

The propensity of others to project their fantasies onto the African continent is rather old. Already during antiquity, Pliny the Elder stated: "There is always something new out of Africa." In the

composition of his *Natural History*, Pliny the Elder contemplated those strange animal species the continent endlessly revealed to the Roman Empire that bordered Africa by way of the Mediterranean coast. Through centuries of conquest, explorers and adventurers projected onto this *mysterious* Africa their most original and most scabrous fantasies. For some, the continent became a sort of wonderland, an outlet for so-called civilized nations to unleash their deepest expressions of repressed barbarism. Everything seemed permitted on the continent—the pillaging and plundering of lives and cultures, genocides (such as the Herero and Namaqua genocide of 1904–7, in what is now Namibia), rapes, scientific experiments—all forms of violence quietly reached their apogee here.

More recently, the winds have finally begun to change, and a spirit of optimism and euphoria has begun to radiate in the light of day. From now on, the future will be African. The continent is making progress in terms of economic growth, and the prospects appear to be promising. Economists estimate that Africa will be the next destination for international investment. Returns on investments will better compensated here than anywhere else in the world. Africa will be the site of strong economic growth that is already beginning to wane in China as well as the other three BRIC countries (Brazil, Russia, and India). Thanks to the availability of natural resources and raw materials, the African continent will be the future El Dorado of global capitalism—a welcomed omen of prosperity during turbulent times.

And yet, what appears to be emerging and expressed are dreams produced by others, during a night of slumber in which those who are most concerned by the development were not invited to the collective dream. One thing is indeed certain: the African people share these hopes for prosperity. What is less certain is whether all the various groups of people share the same enthusiasm for the mechanical and rational forms of an economic order that will

submit the world and its resources to a forced exploitation profiting only a small minority of benefactors, and thereby disrupting the balance of living conditions.

Since Africa *is* the future and it *will be* the future, this rhetoric claims, implicitly, that Africa presently *doesn't yet exist*—that Africa's co-presence with the current times rings hollow. The varying terms of intensity with which we evoke this future time indicate to what degree there is a current lack. In reality, the delocalization of Africa's *presence* into a perpetual future is a debilitating judgment of which it becomes the object. In a variety of ways, we tell millions of people every day that the way they live their lives has no value. In adopting this economic viewpoint along with its statistical abstractions, certain Africans seem to adhere more and more to the mandate of quantity over quality, of having over being; they are content to have their presence in the world be evaluated by nothing more than the statistical data of their GDP or their leverage on the international marketplace.

The current debates about Africa are dominated by this double movement: a faith in a brilliant future and a consternation when confronted with a seemingly chaotic present fraught with a number of different convulsions.[1] In this context there is an enormous temptation to give in to either a catastrophism or its inverted double: a blissful optimism. What is certain, at the very least, is that the various crises under way on the African continent are a sign that it is in the midst of creative gestation. What sort of angel or monster will it give birth to? For now, the half-light in which we find ourselves leaves us little in the way of guessing which will be the case. . . .

Nevertheless, what the African continent is suffering from is more than a mere case of poor self-marketing or a failure in image

1. Multiform political crises, jihadism, civil wars, poor governance, and extreme poverty.

branding; it is rather a deficit in the thought and production of its own metaphors for the future. Africa lacks an autonomous and endogenous teleonomy[2] resulting from its own reflection on its present situation, fate, and the futures it will provide for itself. Human societies have always transformed in an organic manner, confronting the challenges that face them and responding either by surviving or by dying.

Given these circumstances, one might wonder, why even bother thinking about the present and the becoming of the African continent? For the very reason that societies first and foremost establish themselves through their imaginaries.[3] These imaginaries become the forges from which the forms that a society grants itself can emanate for nourishing life as well as enriching it, for elevating human creativity and the adventure of social invention to a higher level. These imaginaries also evolve because they are projected into the future; they think the conditions of their own longevity. And, with this end goal in mind, these imaginaries transmit their intellectual and symbolic capital to the following generations, thereby carrying forward a project for a society as well as an entire civilization; they edify a vision of humanity and define the end goals of social life. The principal task at hand thereby becomes extracting oneself from a dialectic of euphoria or hope, and undertaking the efforts of critical reflection in regard to oneself, one's own realities and situation in the world: to think oneself, to represent oneself, to project oneself. Before undertaking such a task, we must accept the continent in the manner in which it was presented to us at this very moment in its historical evolution, as well as in the manner in which, throughout several centuries, relations of both external and internal dynamic forces have shaped it. As we begin to look at the continent as it truly is, and not as it should be, the continent

2. A purpose of a mechanical nature at work in nature, and which, by extension, would be a purpose posited by groups or individuals.

3. Cornelius Castoriadis, *The Imaginary Institution of Society* (Cambridge: MIT Press, 1998).

reveals its most profound mysteries of the various dynamisms at work throughout its vast landscape.

Thinking Africa implies setting off on a trail toward an uncertain daybreak, a long, *delineated* path where the walker is summoned to hasten his pace to catch the train of a world that appears to have already left the station several centuries prior. Thinking Africa implies clearing the path of a dense and overgrown forest, carving out a trail at the very center of the densest part of the fog, a site steeped in concepts, injunctions supposedly reflecting societal teleologies, a space saturated with sense.

Key words such as *development, economic emergence, growth*, and *struggles against poverty* are, for some, the principal concepts of the dominant episteme[4] of the era. Most of these concepts are the result of the prioritization of the Western dream exported the world over since the fifteenth century, in favor of technological advances—via cannonballs and, when necessary, blunt objects to the skull. . . . But above all, it is by investing in the collective imaginaries, in its own version of human progress, that the West truly won the decisive battle. We must untangle ourselves from this siege so we can once again grant a place for other possibles.

We must think in much broader strokes so as to imagine and invent conceptions of life, of what is livable, and viable, in a mode other than one based merely on quantity and greed. To think a vitality and elevate it to its highest possible level. To envision the social adventure as firstly nourishing life, seeding growth, to help society grow in its quality by inscribing within it a more elevated perspective of what it should be. At the dawn of human history,

4. *Episteme* is defined here as a collection of the scientific forms of understanding and knowledge [*savoir*] of an era and of its assumptions. More generally, it's a way of thinking about and representing the world: a set of dominant values and beliefs of an era that is largely spread out over an entire culture. See Michel Foucault's *The Order of Things: An Archaeology of the Human Sciences* (New York: Random House/Vintage, 1994), originally published in 1966, as well as his *The Archaeology of Knowledge and The Discourse on Language* (New York: Random House/Vintage, 1982).

Africans colonized hostile territories, gaining an initial victory over nature by establishing durable societies, thus allowing for humanity to survive and endure.[5] This is the African peoples' first heritage, prior to the great exodus from the continent by *Homo sapiens*. Today, Africa's task could perhaps be understood thus: in these times of a crisis for meaning within a technical civilization, Africa can offer different perspectives concerning social life, emanating from other mythological universes, thereby continuing to support, promote, and be an exemplary instance of the shared notion for the common dream of balanced and harmonious life imbued with meaning.

Afrotopos is this site of another Africa, one whose arrival we should expedite in order to realize its brilliant potentials. Founding a utopia is not at all a question of simply giving oneself over to sugar-coated reveries, but a matter of thinking spaces of the real to bring them into existence by way of both thought and action; it's about recognizing the signs and seeds of the present in order to better nourish them. Afrotopia is an active utopia that takes as its task the cultivation of vast and open spaces of bountiful possibles in order to help them flourish.

The challenge thus resides in articulating a thought that bears on the fate of the African continent not only by scrutinizing the political, economic, social, and creative spheres, but also by identifying the sites where new practices and discourses have already begun to express themselves, where this future Africa can come into view. Our task will therefore be to decipher the dynamics already under way, recognizing the emergence of a radical novelty, thinking the contents of social projects, and analyzing the role of culture and its various mutations, so as to then take up a prospective reflection. By thinking a different rapport between subject and object, old [*arché*] and new, mind [*l'esprit*] and matter, we

5. John Iliffe, *Africans: The History of a Continent* (Cambridge: Cambridge University Press, 2007).

will also envision the construction of a new civilization that will place humanity at the center of its preoccupations, by proposing a healthier balance between the different orders, be they economic, cultural, or spiritual. This is the task we must set for ourselves so as to seek out new horizons and thereby contribute to the positive transformation of African societies. First and foremost, this task and responsibility resides with African intellectuals, thinkers, and artists. The ambition of this essay is to grasp the contours of such a project.

1

Against the Tide

For a new conception of the continent to flourish, it must coincide with an absolute intellectual sovereignty. For this to happen, one must think this Africa in movement outside of the usual buzzwords—development, emergence, MDGs [Millennium Development Goals], ODDs [Objectives of Durable Development]—which up until now have served merely to project the myths of the West onto the trajectories of African societies. These concepts have failed to take into account the dynamics currently under way on the African continent, have failed to think the deep mutations operating there, as the concepts have relied too much on a Western cosmology that conditions their reading of the real. By inscribing the pace of African societies inside a teleology with universal pretensions, these categories, hegemonic in their claim to qualify and describe the social dynamics at play, have completely denied the creativity inherent within these societies as well as their capacity to produce metaphors for their possible futures. These concepts have stumbled over the cultural, social, political, and economic complexity of African societies, because they have fundamentally lent their frame of reference to other mythological universes.

One of the principal errors of the West comes from what we could call its quantophrenic biases: the obsession to count everything, to evaluate, to quantify, and to place everything into equations. The West is obsessed with creating summaries of the social dynamics at play, in order to transform them into some kind of gauge or measurement that reflects a promising evolution of these

dynamics. The activity of quantification can be useful for pre-
dicting, managing, and anticipating the path that remains to be
traveled as well as respecting its relation to the distance that has
already been traversed; however, in carrying out this mathematical
reduction of reality one runs the risk of surreptitiously transform-
ing imperfect measurements and reference points into the ultimate
aims and end goals of the social adventure.

This brings to the fore questions regarding the evaluation of
social life and its evolution with the typical categories of socioeco-
nomic and sociopolitical indicators. One of the most frequently
used criteria is the measurement of a nation's wealth by way of
its GDP or its position on the human development index. These
aggregates are not satisfied with simply measuring a quantifiable
threshold of "wealth or capacities"[1] that it would be preferable to
attain for the betterment of individuals and populations; rather,
they also attempt to classify and place nations into a hierarchy
based around some sort of normalized ranking system, placing
some nations higher and some lower. Besides the obvious weak-
nesses inherent within this kind of measurement due to the strict
statistical nature of this ranking system,[2] these indicators, specif-
ically linked to living conditions alone, don't really say anything
about life itself. The quality of one's social relationships, their
intensity, their fecundity, social distance, the nature of cultural,
relational, and spiritual life, and so forth—everything that makes
up existence, its lifeblood and meaningfulness, all the reasons for
living—all these vital rapports truly inherent to one's quality of life
pass right through measurement systems like fish through nets too
large to catch them.

1. This concept, developed by the philosopher and economist Amartya Sen,
designates one's aptitude for being and doing what one values.
2. The underestimation of certain dimensions, the omission of produced
surplus value (the informal economy, domestic work, etc.), statistics that are
largely dependent on the specific year referenced for when they are measured.

Efforts are currently under way to enrich these measuring systems and their indicators so as to make them more nuanced and complex in order to better take into account dimensions of life outside the mere notion of added value: education, health, quality of life, the quality of the environment. The last two measurements always fall short when attempting to comprehend and quantify the immaterial dimensions of well-being.[3]

Nevertheless, in a more fundamental way, what must be done away with is the false evaluation of individual and social life. Life cannot be measured by the soup bowl. Life is an experience, not a performance.

Walking in an African city—Lagos, Abidjan, Cairo, or Dakar—is first and foremost an experience for the senses. It is a cognitive experience. You are immediately captured by the city's rhythm. Vitality, creativity, and energy unfurl in the streets; chaos and order are constantly grappling for space; one is confronted by signs of the future coexisting with the past and the present. Instinctively, we can sense that there is something inherently wrong with measurements only based on added value and GDP, as well as the classifications and organizations of the levels of the relative wealth of the various countries. Life, the pulse of society, the intensity of social interactions, the relations one maintains with one's local environment, the simple fact of whether one feels well or ill, the feeling of plentitude—these can't be captured by such statistical measurements. Living within these spaces, being present within them, one loses any notion of relative evaluation: it makes no difference if New York City has a greater number of bridges or highways than

3. In measuring neuronal activity of the production of alpha and gamma rays, stress levels, etc. there are even attempts to pinpoint, by way of an exact evaluation of happiness or fulfillment, an exact measurement of one's psychic well-being. There have also been rigorous attempts at trying to construct a national happiness index (GNH, or gross national happiness) that would replace the GDP.

Abidjan. Upon finishing his workday and heading home, a Sine[4] farmer doesn't ask himself whether or not the land upon which he treads is developed or emergent, or whether or not he belongs to an advanced country. The rains were plentiful this year, the daily work was steady, the crops are promising; overwhelmed by a feeling of accomplishment, he awaits his harvest. His work, more than mere labor, is a work of art that, in providing sustenance for the greater world, seeks to help nourish a larger sustainable life beyond his own.

When night falls on an African city as we're heading home, and we happen to encounter an electrical blackout, we zigzag on a road full of potholes, and for a moment we experience what is lacking or not yet achieved within our current social organization. We genuinely aspire to a more optimal form of society, where the social services and public goods would be more adequate. However, the experience of these shortcomings is integrated and becomes a part of the halo and totality of lived experience. Life forms this indistinct whole, and the feeling of lived experience incorporates experiences coming from different dimensions of existence, experiences connected to comfort where the optimization of social organization becomes mixed up with those experiences connected to a quality and intensity of lived experience (the latter forms of experience can even prevail over the former).

Envelopment

Development is one of the West's entrepreneurial expressions, an extension of its episteme in the world by way of the dissemination of its myths and social teleologies. It has become one of the most powerful mythemes of our current era. All societies rely on myths for justifying their evolution and their appropriation of the future. After colonialism had definitively discredited the idea of a

4. Sine is a region in the west-central part of Senegal largely inhabited by the Serer.

civilizing mission, development erected itself as an unquestionable norm of progress within human societies by inscribing their progressive movement within an evolutionary perspective, thus denying a diversity of trajectories as well as the modalities of responses to the challenges that are posed to them.[5]

Development is therefore an attempt to universalize an enterprise that originated and reached its highest degree of realization within the West.[6] It is first of all the expression of a thought that has rationalized the world before having the means to transform it. This rationalist and evolutionist vision of social dynamics was received with such success that it was basically adopted by nearly all of the newly decolonized nations. The greatest feat of this vision was to posit Western societies as referents and to disqualify any other trajectories and forms of social organization. As such, by way of a kind of retroactive teleology, every society that was different from Euro-American societies was automatically considered *underdeveloped*. The conversion of the majority of nations to this passion for Western-style development was a masterpiece in the negation of difference.

The apparent objectivity of its criteria of evaluation (GDP, individual revenue, level of industrialization, etc.) helped to propagate this enterprise of rationalization and the standardization of societies founded upon the utopia of a determinist and predictable world.[7] With the seventeenth century, we see in the West the birth of the idea of the possibility of an infinite progress within the field of the social and the various forms of knowledge [*connaissances*].[8]

5. In the aftermath of World War II, the American president, Harry Truman, was one of the first to propose aid to *economically underdeveloped countries*, that is, countries lagging behind the United States in economic development.

6. Jean-Marie Domenach, "Crise du développement, crise de la rationalité," in *Le mythe du développement*, ed. Candido Mendès (Paris: Seuil, 1977).

7. This was a result of the thinkers of the Enlightenment and the scientific positivism of eighteenth- and nineteenth-century Europe.

8. This idea was put forth by Descartes, Leibniz, and Pascal during the debate between the ancients and the moderns.

Its corollary is that there exists something we could call a natural history of humanity and that the development of human societies, of forms of wealth and knowledge, corresponds to a natural principle that is autodynamic and which established the possibility of a narrative.[9]

By way of analogy, this social evolutionism follows the theory of biological evolution. The possibility of the unlimited progress of societies, reflected in the continual growth of the GDP, is a terrestrial and profane translation of the concept of infinity within the kingdom of heaven in Christian eschatology. *Progress, reason, growth, order*—these will become the keywords of the episteme of modernity in the West.

At an etymological level, developing is the opposite of winding down, or enveloping. Development becomes a question of setting the stage for growth, for a kind of unwinding, a deployment. In reality, we only ever develop what is already there, latent in its potentiality. What was proposed to Africans was a one-size-fits-all societal model. In order to organize their political, economic, and social spheres, African nations were asked to dress their institutional forms using institutional fabrics, produced from an ancient history that was born elsewhere and whose initial founders could not have imagined the contours it would take on. In the place of, and substituting for, a fortification of the unique qualities and singular characteristics of every people, the imposition of a single model, translated by way of the injunction of a *being like* instead of the model of a *being something else or something more*, resulted in a *being less than* for each unique culture. This substitution of a Western cultural and societal mode of progressive development literally became a work of enveloping non-Western societies inside societal forms that were not in the least bit harmonious with their non-Western ways of life.

9. Gilbert Rist, *Le développement: Histoire d'une croyance occidentale* (Paris: Presses de Sciences Po, 2013).

Instead of illuminating reality, this proclamation of development became an ideology: an entanglement of ideas that ended up concealing reality by justifying a different praxis and order of the real which ideology is supposed to be accountable for. Out of two hundred countries in development since the 1960s, only two have gone from being countries with weak income streams to countries with strong income streams. And only thirteen have successfully attained the status of countries with intermediary income levels necessary for joining those countries considered to have elevated incomes. These few miracle nations are there to feed the fires of belief, but in reality they represent the painful failure of the promise of prosperity made to the nations that embarked on this path of development. Certainly, one could make the claim that the nations didn't properly apply the model, and this is precisely where the crux of the problem resides. Development is supposed to be the result of a passage from *potentia* to *actus*.[10] To use an analogy from biology,[11] development is the process whereby the embryo is deployed and in which the life-form then moves toward its state of maturation. In this sense, development implies two things: the definition of a final stage toward which beings develop, but also a *potentia* of latent elements to be achieved.

But do we, as a society, truly realize ourselves by way of the modes of imitation, grafting, and extroversion? Through the injunction to adopt social structures, mentalities, significations, and values that are not the result of the actualization of our own potentialities? The answer is obviously a resounding no.

At the origin of every community there is the establishment of a common symbolic code that allows for its members to think,

10. Cornélius Castoriadis, "Développement et rationalité," in Domenach, "Crise du développement, crise de la rationalité," in Mendès, *Le mythe du développement.*

11. The problem with using the analogy of biology would, however, be the transfer of processes that take place within the organic order of the living [*du vivant*] onto sociohistorical realities.

speak, and take part in the experience of the real in a relatively univocal way. Anthropology has shown that societies rely on a founding narrative, a myth, which shapes a certain conception of the world and its organization, establishing a hierarchy of particular values that are often conceptualized through a civil code and linguistically internalized by its members. Modern societies—more specifically, Western industrial society—do not escape this structure. Western industrial society must legitimize its evolution and its appropriation of the future by way of a mythology that reflects its cosmologies and social ideologies. From this perspective, economic discourse functions as an *ecomyth,* guaranteeing the maintenance of the industrial social order. It helps to nourish the representations of the universe and society, legitimizing institutions, affirming belief systems, shaping the various modes of living and thinking that allow for the organization and assemblage of reality, thereby conforming to the message initially constructed by the foundational narrative. *Well-being, progress, growth,* and *equality* are the key concepts of Western cosmology that condition its reading of the real, a reading that it imposed onto other peoples and nations through the mytheme of development.

As such, the plan that was proposed to Africans consisted of reproducing a prefabricated model of society in which their local culture had no preestablished role to play or whereby the African cultures were often simply evaluated in an entirely negative way.[12] Not to mention that Western development is not simply an economic project but above all a cultural project resulting from a particular universe. One of the consequences of this transposition of the Western myth of progress was a destructuring of the fundamental personality of African social groups, of the preexisting networks of solidarity and systems of signification that were

12. Axelle Kabou, in *Et si l'Afrique refusait le développement* (Paris: L'Harmattan, 1991), explains the poor development of the African continent by way of an inability of African cultures to adapt to progress.

in place. But above all, this erroneous myth led to an enclosure of populations within a value system that was not their own.

This ecomyth became hegemonic in part through its projection of the West's vision of progress and end goals of the social adventure onto African societies, and in part through its temptation to inform all social practices. Hence the necessity for the majority of African countries to create a political, economical, and social project that was derived from their own socioculture and emanated from their own mythological universe and worldview. Here, the question of the dialectic of the particular and the universal is posed within the economic and social field. To attempt to respond to the fundamental needs of a social group by a process, by a project, is a universal obligation shared by all societies. The practical modalities for achieving this, the definition and hierarchy of needs, the establishment of a scale of values—these are themselves multiple and varying in response to the unique individual spirit and brilliance specific to each human group.

We must proceed by way of a philosophical, moral, and political critique of the ideology of development. Development is a form that history brought into existence in order to respond to the needs of Western societies. The folly of the modern West consists in positing its specific manner of reason as sovereign.[13] This Western reason reflects nothing more than a single moment in time and, as such, only one dimension of thought. And when this type of reason becomes autonomous, it becomes maddening or delirious.

In a more general way, what we're speaking about is the vital necessity of extracting ourselves from the mechanical reign of reason that no longer responds to the multiple injunctions of the dominant economic order (the order of development, emergence, economism, uninterrupted growth, mass consumption). The global economic crisis that we are living through, along with

13. Castoriadis, "Développement et rationalité."

its diverse manifestations, shows very well where the limits of this order reside.

Above all, what we must take into consideration from this situation is a question of a moral, philosophical, and spiritual nature: we are dealing with a crisis of a material and technical civilization that has lost all bearings regarding its priorities. What is necessary is to remove ourselves from our dependence on the rational and mechanical model that has dominated the world. In offering up an inverted perspective of man, this mechanical model has wanted to claim itself the *master and possessor of nature*, and as a result it has ordained the mandate of *quantity* over *quality*, of *having* over *being*.

The African continent is a land of diversity. From Algiers to the Cape of Good Hope, it is the site of a proliferation of cultures, peoples, historicities, geographies, modes of social and political organization, and various temporalities. But despite this diversity, which is one of its most cherished resources, all the nations of the African continent share the same fate and have to confront the same historical challenges. They all share the same recent history, but above all they share the project of an Africa that must once again become its own source of "power and light."[14] Of course, this requires resolving the question of social and political imbalances, and, in order to do this, sketching out fresh contours of the political sphere. But we must also respond adequately to the fundamental economic needs of the African peoples. To achieve this goal, we must creatively *rethink* the economic sphere while at the same time respecting to the utmost man's dignity by creating an economic sphere where the means are subjected to societal ends defined by the group.

But above all, this response must not become captive to a thought based on necessities, where the economic sphere would

14. I borrow the expression "power and light" from Achille Mbembé, who used it during a conference concerning the Colonial Library in Dakar organized by CODESRIA and Africa n' Ko in January 2013.

be subordinated to a technique striving to seek out precise ends. A civilization does not achieve its goals simply by tapping into the value of its material resources; a civilization's material resources are made whole by way of spiritual values that give them meaning.

There must be an articulation of societal projects responding not only to the material needs of the individuals but also to their cultural and spiritual needs.

Within a global context where the project of civilization has broken down, the African utopia will consist of opening up other paths for living together and rearticulating the relations between the different cultural, social, economic, and political spheres, by creating a new space of signification, and by organizing a new scale of values that would be founded upon its own cultures and fertile ontomythologies. Constructing societies that make sense for those living within them. Going against the tide of Western globalization, charting their own course.

2

The Proposition of Modernity

Modernity is largely considered an ensemble of historical conditions that provide ways to think the emancipation of the individual vis-à-vis values arising out of traditional culture. Some in the West[1] consider modernity's starting point as the Renaissance, whether beginning with the capture of Constantinople in 1453 or the encounter with the *new* world (1492). Modernity is often associated with the pursuit of Enlightenment ideals. It was essentially a desire in the West to posit reason as the foundation for social, political, and cultural organization. As a philosophical concept, modernity is the project of imposing reason as the transcendent norm for society instead of and in place of God, ancestors, or tradition. What we call "modern times" is the moment when humankind's knowledge liberated itself from nature and the divine, and when humanity began to refuse to draw its legitimacy from anywhere other than itself.[2] The two faces of modernity are therefore reason and the subject. The list of modernity's so-called conquests include the various sciences, technologies, forms of democratic organization, and the rights and freedom of the individual subject.

However, in the twentieth century Jürgen Habermas begins sketching out what he sees as a crisis of modernity in the West.

1. Authors such as Shmuel N. Eisenstadt contest the uniqueness of the genesis of modernity in the West; see "Multiple Modernities," *Daedalus* 129 (Winter 2000): 1–29.
2. Rémi Brague, *Le règne de l'homme* (Paris: Gallimard, 2015).

In Habermas's opinion, the remarkable development produced by the instrumentalization of reason had made man a slave to the social constraints produced by this instrumentalization. Despite the extreme importance of the rights acquired by the subject (individual freedoms, republican democracy, etc.), these achievements seem more important within the areas of science and technology than within morality and politics.

For Habermas, modernity is an unfinished project that humanity must continually take back up in order not to precisely lose its humanity. After the Great Depression, Auschwitz, Hiroshima, and the gulag, the grand narrative of humanity's progress by way of reason subsided. Throughout the course of history, reason progressively lost its capacity for proposing universalizable goals. Hence the necessity to fight against the triumph of modernity's instrumentalized version in order to rediscover its initial meaningful purpose of searching for end goals and their determinations. Concurrently, in the 1950s and 1960s in Western Europe, the great cultural orientations began to fall apart: the family, the nation, responsibility and duty, the compromise between the importance of the collective and the juridical recognition of the fundamental liberties of the citizen. The sacred crowning of the individual, the cult of hedonism, the individual belonging to several different groups [*polyappartenance*], the fragmentation of identity, the mobility of social practices, the dissolution of the feeling of responsibility toward the community—all this will characterize what theorists such as Jean François-Lyotard[3] will call postmodernity: the sudden dissolution within contemporary Western societies at the end of the twentieth century of the reference to reason as a transcendent totality. From then on, the significance of individuals' actions is dissociated from a common order that would bestow meaning on them and

3. Jean-François Lyotard, *The Postmodern Condition*, trans. Geoff Bennington and Brian Massumi (Minneapolis: University of Minnesota Press, 1984).

is replaced by purely self-referential and automatic regulations. Gilles Lipovetsky[4] will speak of a hypermodernity. Hypermodernity is characterized by a hypertrophy of modernity: an excess in all directions (gigantic supermarkets, hypertexts, billions of websites, hundreds of television channels, cloning, extreme sports), a sense of urgency of the present instant, sensations, and the advent of a kind of a man of instantaneity [*l'homme-instant*].[5]

This postmodernity is also viewed as the symptom of a profound crisis of civilization that has led to an extreme fragilization (depression, suicide) of the individual in the West.

Rethinking a Relation with Tradition

Within the African context, tradition is often pitted against modernity. Modernity will be defined as that which is substantially opposed to conceptions of value and systems of reference—basically, opposed to the epistemes arising out of tradition. The colonial library[6] outlined and classified African traditions as being characterized by an immobile temporality resistant to the march of history and progress (Hegel, Hume, Rousseau, Kipling). The invention, discovery, or adoption of an African modernity would therefore be nothing more than a case of this liberation or uprooting from tradition, the negation of the old, most notably in its capacity, from then on, to regulate current social practices. Modernity would thus be the fashionable attire of the present times, a clothing fabricated elsewhere and which we must bring ourselves to wear to be in tune with the world—even if it means having to shorten an arm or a leg in order for the clothes to fit. Conforming to the

4. Gilles Lipovetsky, *L'empire de l'éphémère* (Paris: Gallimard, 1987); *Le crépuscule du devoir* (Paris: Gallimard, 1992); *L'ère du vide* (Paris: Gallimard, 1983).

5. For more on this concept, see Nicole Aubert's *Le culte de l'urgence: La société malade du temps* (Paris : Editions Flammarion, 2009).

6. The expression "colonial library," coined by Valentin-Yves Mudimbé, designates the collection of texts written by European explorers, anthropologists, and ethnologists about the African continent that largely contributed to constructing the vision and imaginaries associated with Africa.

demands of the moment: this is what being modern amounts to. It is worthwhile to explore the terms of this dialectic of tradition–modernity created out of an opposition and mutual exclusion, as well as the vision of modernity as pure exteriority.

For Oscar Bimwenyi-Kweshi,[7] tradition is the site where we see the configuration of the fundamental spiritual values that give life meaning. Tradition is the anchor of the dynamic of becoming human for the African man. Jean-Marc Ela[8] only refers to this tradition of values with a view toward their possible enrichment within contemporary living situations: within concrete sociopolitical relations where we see a reharnessing of the energies that culture creates. He assigns a mission to modernity: that of forging a new African humanity within the context of a modernity gone awry, whose achievements in the realms of science and technology are only part of the effects of modernity's wrath, which, for the moment in Africa, have produced nothing but inequality, poverty, and feelings of abandonment. What is at stake is to free oneself from everything—within modernity as well as tradition—that diminishes the human being and thereby destroys his energy and creativity, delivering him up bound and gagged to the monstrous structures of a relentless global economic order.

Tradition and modernity appear both as internal realities and as a bundle of questions posed to the African's being in the world. What has become urgent is the need to rearticulate these realities and questions according to principles of cross-pollination. For Georges Ngango[9] it's not simply a question of Africa refusing lessons acquired from external experiences from those countries

7. Oscar Bimwenyi-Kweshi, *Discours théologique négro-africain: Problèmes des fondements* (Paris: Présence Africaine, 1981).

8. A Cameroonian theologian, author of *La plume et la pioche* (Yaoundé: Clé, 1972) and *Cri de l'homme africain* (Paris: L'Harmattan, 1980).

9. See Georges Ngango, "L'Afrique entre la tradition et la modernité," *Éthiopiques* (November 1976), in a special volume of the black African socialist revue for the celebration of the seventieth birthday of the first Senegalese president, Léopold S. Senghor.

already following the economic, political, and technical path of modernity; it's about locating the various indispensable levels of contact as well as the limits assigned to values that Africa must accept as positive factors for its own enrichment.

Going against the tide of an essentialist vision of tradition, Paul Gilroy suggests viewing tradition as a "changing same" that "strives continually toward a state of self-realization that continually retreats beyond its grasp."[10] The path toward an African modernity would consist of the selective incorporation of technologies, discourses, and modern institutions with Western origins inside the African cultural and political universe in order to give birth to a distinct and autonomous modernity. These analyses share the common idea that African modernity remains to be invented, that it must be thought of as a graft that will succeed in being accepted by way of a selective incorporation of practices and institutions that are initially foreign to it.

The thought of alternative modernities, as theorized by Charles Taylor, Dipesh Chakrabarty, Michael Hanchard, and Dilip Gaonkar,[11] postulates that modernity, as much societal as historical and cultural, is a process by which the West constitutes the original site of deployment. However, as a result of cultural exchanges, migration flows, and colonialism, modernity has been imperfectly dispersed beyond its original source. As such, the West is no longer the sole purveyor and agent of modernity. Modernity's avatars have become multiple and diverse, and they can be found within all cultural geographical areas. Western modernity itself[12] is a synthesis of different contributions from the various worlds with which it came into contact. The perspective

10. Paul Gilroy, *The Black Atlantic: Modernity and Double Consciousness* (London: Verso, 1993), 122.

11. Dilip Gaonkar, ed., *Alternative Modernities* (Durham, N.C.: Duke University Press, 2001).

12. It is important to distinguish between modernity (reason as the fundament of social, political, and cultural organization), modernism (a nineteenth-century artistic movement), modernization (the incorporation of technology

of alternative modernities is a proposal for the re-narration of the modern that insists on the diversity of its incarnations as well as the decentering of modernity's relation to its Western kernel. According to these alternative thinkers of modernity, the idea that modernization leads to a uniform model of social organization is entirely wrong and misleading. The invention of the modern produces completely unexpected forms under the variety of different skies where it takes hold (Russia, Trinidad, Beijing, Lagos, Johannesburg). The invention of the modern can only produce multiple and very specific actualizations. Schmuel Eisenstadt[13] theorizes the existence of multiple modernities and rejects not only the Western genesis of this idea but also the exclusivity of the universalism this concept seems to carry with it. The black African civilizations—as well as those of Islam, Hinduism, and Judaism— all contain at their core their own projects of universalism based on reason. The question of the common good, of the general will and the autonomy of the individual, has always been a part of these other civilizations. And for some of these civilizations, their universalism would have perhaps been better off without the contamination of imperialism.

The Reinvention of the Self

African societies are living through a crisis linked to the viability of the practices that formerly regulated social life. The old forms of social life no longer work as well as they once did, and the transition toward new forms for the regulation of social life has been slow in actualizing itself. And as a result, African societies have been called to reinvent themselves in order to confront the economic, cultural, political, and social challenges that have emerged. The contemporary African is torn between a tradition that he no longer truly feels attached to and a modernity that has befallen

and innovations into the processes of social organization), and modernist (in art, and that which is opposed from the old).

13. Eisenstadt, "Multiple Modernities."

him like a destructive and dehumanizing force.[14] Remember that one of the most striking points of contact with Western modernity through colonialism was the "encounter with the hideous face of the other."[15] One of the effects of colonialism was the radical upheaval of the personalities of these social groups. As such, Western modernity elicited both a fascination and revulsion for the African. The protagonists in Cheikh Amidou Kane's *Ambiguous Adventure* and Valentin-Yves Mudimbé's *Between Tides* are archetypes of this oscillation. Tossed about between two cultures, the interiority that the protagonists must grasp and reconstruct is problematic because it is splintered and divided. The African is highly aware that he is at ground zero within a world order where his fate has been completely turned upside down, where he must reinvent his fate and raise it to the level of the stakes at hand,[16] stakes that he himself will have defined as crucial. He must learn to inhabit a world that will be truly his own because it will correspond to his rediscovered and reimagined being.

Frantz Fanon,[17] by way of a critique of the imaginaries of Western modernity, insists, however, that this reinvention of the self must not be a mere pale imitation: "So comrades, let us not pay tribute to Europe by creating states, institutions and societies that draw inspiration from it. Humanity expects other things from us than this grotesque and generally obscene emulation. If we want to transform Africa into a new Europe, then let us entrust the destinies of our countries to the Europeans. They will do a better job than the best of us. But if we want humanity to take one step forward, if we want to take it to another level than the one where Europe has placed it, then we must innovate, we must be pioneers."

14. Kä Mana, Congolese philosopher and theologian, "Penseurs d'Afrique et la modernité," available at www.congoforum.be.

15. Aimé Césaire, *Discourse on Colonialism,* trans. Joan Pinkam (New York: Monthly Review Press, 2001).

16. Kä Mana, "Penseurs d'Afrique et la modernité."

17. Frantz Fanon, *The Wretched of the Earth,* trans. Richard Philcox (New York: Grove Press, 2005), 239.

An African Modernity?

The Westernization of Africa has been in progress since the beginning of colonization: official languages, educational systems, administration, economic organization, and other institutions have taken on Westernized forms on the African continent. Nevertheless, social structures resist completely merging with these various Westernized forms and the value systems that arise from them. One can identify a disjunction between the grafted institutional forms and the mental frameworks and systems of meaning that continue to produce, within various spaces, the different organizational forms of these institutional frameworks. The train has not yet achieved its proper cruising speed, and what we can see is some kind of hybrid form denoting the unfinished, incomplete nature of the ideal form continuing to emerge. These forms in gestation indicate the work of rearticulation under way. If an African modernity truly wishes to avoid becoming a poor counterfeit of Europe, what are its possible contours and contents?

African intellectuals[18] have written at length on the sociopolitical dynamics of the continent and have done so for many years. Luc Ngowet[19] estimates that the contours of an African modernity can be grasped through a discourse that is specific to Africa, one that is not simply reduced to the words of anthropologists and Africanist political scientists. Beginning in the sixteenth century, there were already African thinkers who were preoccupied with their lived experience and their relation with modernity. The intellectual elite of the Sonrai empire—specifically, Ahmet Baba

18. These intellectuals have written on power, liberty, democracy, the rule of law, development, ethnicity—juridical, historical, and theological texts having a critical and reflexive character. In Ethiopia there is even a large philosophical oeuvre written in Amharic. In the twentieth century, Senghor, Nyerere, and Nkrumah produced their versions of African political thought.

19. Luc Ngowet, "Qu'est-ce que la pensée politique africaine: Fondements théoriques," seminar on African political thought, Collège international de philosophie (CIPH), 2014.

from Timbuktu—reflected on the influence of Islam on the lived experience of African politics. According to Luc Ngowet, African modernity cannot be reduced to a specific moment (such as the independence of nations) or to an era with a variety of temporalities, nor to processual phenomena (modernization, industrialization, or the societal waning of technical progress). African modernity is a historical and psychosocial continuum resulting from a series of political events that have marked Africa's history. The encounter with the other (the East and the West) constitutes one of these moments; but there are also the events such as the independence of African nations, the postcolonial period, the periods of democratic transition. As such, African modernity can be perceived as this immediate lived experience of individual and collective Africans. This African modernity is the result of a dual historical and psychosocial movement. This African modernity is not something that needs to be invented: it is already here. However, it bears contradictory tendencies that are always in negotiation; the task then becomes one of grasping the ideological representations and imaginaries underpinning this quest for a better quality of life together that already reside within this African modernity.

Afro-contemporaneity

In positing, right from the outset, that modernity is a teleological concept, the reflection becomes inherently flawed. But we posit this flaw within modernity as a necessary occurrence within the emergence of societies, and we do this by considering it from an evolutionary perspective. Furthermore, instead of thinking the social dynamics under way in the manner in which they present themselves and then extracting meaning from them, we will content ourselves, on one hand, to trace the presence or absence of the signs of modernity within the real of African societies, and on the other hand, to posit as signposts its philosophical principles (the apologia of the new, reason as the foundation of social

organization) and the institutional forms it provides for itself. As such, in simply measuring the distance separating various African societies, we condemn ourselves to experiencing the pangs of comparison, perpetually thinking of ourselves like some sort of straggler, always striving to catch up in order to gain a place in the various rankings that constantly remind us how we've fallen behind. This leads the becoming subject to fall prey to the good-student complex. This desire to reprise forms of social organization deemed modern and to wed philosophical concepts to them is initially the result of a forced grafting that resulted from the colonial encounter. But this desire endures through the action of African elites who have been won over by the Western dream, fascinated by its technological achievements, and who desire to identically reproduce its societal forms. This is the same tendency we see within the uncritical adoption of European temporal periodization (antiquity, the Middle Ages, the Renaissance, modern times, contemporary eras), and above all the significations associated with that temporal periodization to name and think its own historical cycles. Rémi Braque remarks that modernity is a kind of arbitrarily placed cursor. Every era is more modern than the one it follows and less modern than the one that comes after. Expressions of African modernity—a modernity that is endogenous, alternative, multiple, and so forth—are simply manifestations of this mimetic desire that, for want of the capacity to replicate the same, thinks itself as an avatar. Aimé Césaire says he prefers hell to an absurdly failed reproduction of heaven.[20]

What are we to do, then, with everything that exists, emerges, lives, and grows, developing outside of these categories and concepts? Because this entire reality remains unnamed, uncategorized, and unconceptualized, it is caught within a formless magma, a heavy mass that nevertheless determines the deep movement of

20. Aimé Césaire, *Moi, laminaire: Poèmes* (Paris: Seuil, 1982).

African societies, like those black holes whose existence we have detected by way of their force of attraction even though light can in no way illuminate their presence. To a certain degree, Africa's inability to name its present reality explains its terminological mimetism. It becomes a question of attaining the possibility of expressing oneself and above all thinking for oneself, outside the civilizational injunctions of others. To name one's own contemporaneity is to inscribe it within a project: to give it meaning, indicating the values it must accomplish, and to create a space and an environment where these values can be accomplished. Afro-contemporaneity is this present time, this psychological continuum of the lived experience of Africans, incorporating its past and with a ripe future ahead of it, a future in need of thinking. In order to grasp all these significations, what is urgently needed is the elaboration of new social and political theories that reflect the social dynamics under way within African societies.

The notion of the contemporaneity of several worlds[21] seems to describe rather well the situation of contemporary African societies, characterized by a process of political, social, and cultural mutations: a transition from the old toward the unfinished new; a juxtaposition, at the heart of the same society, of different temporalities and epistemes, sometimes residing in one and the same individual, where several systems of reference can reside, negotiate, enter into conflict, or cross-pollinate. Some individuals live within both a traditional temporality and an era said to be modern or postmodern. As the cultural values of a society are constantly being redefined, the African societies in mutation are symptomatic of this permanent renegotiation of their cultural references and this contemporaneity (transversality) of several worlds. One of the challenges of this afro-contemporaneity will be to succeed in affirming itself within its fruitful differences, all while not falling

21. I take this notion from Catherine Quiminal's *Gens d'ici, gens d'ailleurs* (Paris: Christian Bourgois, 1991).

into the extremes that a closed-off communitarianism would constitute.[22]

Orthogenesis and Cultural Mutation

This Africa that *exists* and that is becoming is protean. Its reason is plural. It has not disenchanted its worlds. Its spiritual life is still bountiful and flourishing. Africa's religions, music, art, cities, the continent's relation to itself, to its body, Africa's presence within time—all these elements bear witness to the daily self-invention under way. Africa is actualizing its own syntheses of the religious, political, and cultural spheres. The open-air laboratory that Africa constitutes has its foundries working at full speed, feeding them with fuel gleaned from all fields. Nevertheless, Africa must establish durable foundations for its overall stability, prosperity, and future to shine bright. In order to accelerate its cultural mutation and to give birth to the new creation that it is carrying inside, the question concerning the mode of the elaboration of its representations is a crucial one. Achille Mbembé[23] notes that these representations are forged at the intersection of indigeneity and cosmopolitanism. He affirms that there is a work of reassembly under way across the continent and that Africa is in the midst of effectuating this synthesis through the modes of disjunction and redistribution. Mbembé predicts that something fertile will arise from out of this African soil: an immense cultivation of material and things, capable of opening up an infinite universe that is extensive and heterogeneous; a universe of plurality that is wide open.

This cultivation could open itself up to an *infinite universe*, whose mastery it will be necessary to attain through the orientation of its evolution (orthogenesis) by the thought and articulation

22. Alain Touraine, *Can We Live Together? Equality and Difference,* trans. David Macey (Stanford: Stanford University Press, 2000).

23. Achille Mbembé, *Sortir de la grande nuit: Essai sur l'Afrique décolonisée* (Paris: La Découverte, 2013), in English as *Out of the Dark Night: Essays on Decolonization* (New York: Columbia University Press, 2020).

of an African social project that has as its end goal the completion of its economic, cultural, and social mutation through the guidance of this very mutation itself. It will be a question of recognizing these goals at the sites where discourses are produced that Africa has created for itself: within the spheres of culture, art, religion, demography, urbanity, and politics.

Social change is not only organic. Above all, it is thought and situated within a context where different forces are at work, affecting the dynamics of a continent that is still highly vulnerable to external shocks. One of the spaces where these various struggles are actually at stake is within the definition of public politics and the future markets on the African continent. Social forces, lobbying groups, multinational firms, international institutions, NGOs, religious movements, and mass media are all facing off. Having been transformed into a construction site throughout the entire continent, the political economy is above all symbolic, and the stakes reside in one's ability to know which groups and which interests will profit from this symbolic political economy, but also which cultural models will impose themselves because of it. Within this context, what becomes of the utmost importance is the question concerning political, intellectual, and cultural sovereignty that allows for the execution and orientation of one's own choices: having the power at one's disposal to select, from the *plurality* of possibles being sketched, those that will lead us toward open spaces that we will have chosen for ourselves.

Periods of rebirth occur in societies through the articulation of a social resilience and a cultural mutation. We could use Japan as an example. During both the Meiji era and the aftermath of the bombings of Hiroshima and Nagasaki, Japan was a nation that was able to regain its modernity and prosperity through its capacity to execute a cultural mutation through incorporating the cultural techniques that arrived on its shores from the West, while also being attentive to hold steadfast to the living heart of its own traditions. A society must also attain a self-relation shed of cultural

complexes and revamp itself with an eye toward tradition, without succumbing to self-hatred or fetishism. In large part, it is these traditions that have lent Africa its strong character of social resilience. Throughout time, Africans have cultivated the values of endurance, courage, and patience in order to withstand a variety of shocks in their recent history. They have also cultivated values for living together, through original methods: the commonplace acceptance of an extended family of friends as cousins [*le cousinage à plaisanterie*], an enlarged notion of filiation and family, interethnic mobility, the capacity for the integration of difference, the incessant weaving and reweaving of social ties . . .

Every tradition contains within it a symbolic and mental capital that can be mobilized and set into action if one wants to fully actualize all of its potential. Above all, one shouldn't simply create a tabula rasa out of a tradition's various legacies. Nevertheless, in order to conserve from these traditions what is vital and fruitful, a spring-cleaning of these legacies is in order. This revamped relationship with tradition implies that once this tradition has been reassimilated we breathe back into it a regenerative energy: hence the necessary work of choice, of pruning and selection. Contemporaneity, elsewhere envisioned as an uprooting, can here be constructed as a fruitful rearticulation with the pulse of traditions. In its most concrete translation, we can call this contemporaneity an effort for institutional, economic, and societal innovation.

It's about thinking the mechanism of social regulation responding to the demands of the moment, and at the same time providing a place for traditional and customary forms that have already been tested which have demonstrated their value and continue to do so in areas as diverse as conflict resolution, restorative justice,[24] and forms of representation and legitimization. It's about granting

24. In Rwanda, in order to confront the challenges of exercising judgment on thousands of individuals after the genocide of the Tutsi, we saw the rehabilitation of a traditional form of restorative justice, the Gacaca court, which proved its worth and demonstrated its effectiveness.

oneself a civilizational context and not resorting to some sort of barbarism that would be the simple negation of old, traditional forms and their reliable insight or know-how for transmitting certain processes and methods that continue to work very well.

The African continent would do well to envision the diversity of its rich cultures as forces of adaptation to change and mobilize them around new societal concerns. One of the most urgent concerns is the elaboration of a true democratic culture[25] that emancipates the various kinds of intelligence, forces, and energies of a young and vibrant continent, gathering these myriad forms of intelligence together for helping with the construction of a better collective and individual well-being. For this to happen, we must take back into our possession not only the continent's political spaces (from the inside as well as the outside) but also Africa's resources so as to rethink and reevaluate its economies, its institutional forms, and reinsert them within a variety of sociocultures.

There are two fundamental resources for achieving these innovations: autonomy and the proper amount of time. The former allows for the execution of one's choices: taking the time to try things out, to experiment, to carefully gather up various flowers coming from a variety of different gardens, to delight in their fragrances and to serenely arrange the bouquet according to the art of flower arrangement. The latter is the refusal of externally imposed

25. For decades, contemporary African societies have accelerated the production of contemporary forms of living-together. Well before the Arab Spring, the 1990s saw the acceleration of a profound enrichment of democratic processes in sub-Saharan Africa through national conferences and a variety of engagements in political discussions and dialogues initiated by African Civil Societies: struggles for the creation of constitutions instituting multiparty systems, the limitations of mandates, the growing recognition of women's rights within familial codes, etc. The desire for democracy as the participation of all within the workings of the city is largely anchored within African societies, as has been shown by an Afro-barometer, focusing on thirty-five African countries, that questioned individuals about their preferences in terms of the modes of political governance and, among other questions, what democracy meant to them.

cadences, in order to establish the proper time necessary to complete one's experiments. This is the time of the forge, the time necessary for combustion and the formation of alloys and metals. This autonomy also means refusing to allow oneself to get caught up in some kind of race; there is no one to catch up with, only to become the best version of oneself. And in order to do this, one can, if necessary, close oneself off from all centrifugal injunctions, including the silent ones. In short, what's needed is a will to reconstitute one's own epicenter and to grant oneself the necessary time for one's experiments to achieve their end goals. All great civilizations at a certain moment were able to become autonomous, to choose the nature of relations established with the rest of the world, to provide the time needed for tending to their young seedlings in the societal garden so as to be open-minded for any possible happy syntheses.

The Question of the Economy

The way in which the question of the economy has been envisioned on the continent is symptomatic of the general form of discourses about Africa. The economy has been analyzed mainly through comparison and, particularly, in terms of deviation. When economists sought to understand the determining factors of economic growth in African countries, they focused their examination on the causes of an absence of growth and, above all, on the difference in level of wealth compared to countries considered as *developed*.[1] The second characteristic is the short-term analysis, or more precisely, what I call thought from the trough of the wave. A certain economic historiography only thinks about the continent

1. Economists such as Paul Collier, William Easterly, and Ross Levine, who are working on the African continent, are focused on explaining the reasons for what they call the "failures of African growth" or the "lost decades of growth" in Africa. Taking as reference points the worst performances of the 1980s, they concluded that there was an opaque mystery that must be elucidated. There will need to be, notes Morten Jerven, nearly two decades of growth on the African continent for them to begin to readjust their discourse on the growth of these countries. The strength of their metaphors ("the lost decades of growth, the bottom million, the snares of poverty") had greater impact on perceptions of this opinion and sometimes even on those of academics than did the reality of empirical data. When Tanzania doubled its revenue per habitant, increasing it from $500 to $1,000, instead of investigating the determining factors of its growth, Tanzania's revenue was compared to that of Japan, which at that time was $20,000 per habitant. See Daron Acemoglu and James A. Robinson, *Why Nations Fail: The Origins of Power, Prosperity, and Poverty* (New York: Crown, 2012). For further developments on this aspect, see Morten Jerven, *Africa: Why Economists Get It Wrong* (London: Zed, 2015).

going back to the 1960s, the period when many African countries gained independence; sometimes it goes back to colonization, with the slave trade being its most distant temporal horizon. In either case, this is where things get lost in the fog. From this point of view there is no economic history outside of the specific moments chosen as points of reference. A longer-term economic history of the African continent reveals a complex trajectory and allows us to reposition these stylized facts within a longer perspective.

Geography, Agriculture, and Demography

Geography is an important factor in economy. It determines the type of agriculture practiced, the natural and minable resources available, the ecological niche, the methods used to circulate people and goods, the types of technology produced or adopted. However, economies shouldn't only be defined by geography. Many peoples have known how to make the best of difficult geographies and, inversely, sometimes have made poor use of favorable zones.

Africa is a continent with a surface area of roughly 30 million square kilometers, composed of fifty-four states. The United States, China, India, and a part of Western Europe can all fit inside the geographical area of Africa. Populated by nearly 1 billion people, with a growth rate of 2.6 percent, fifty years from now Africa will be the most populated continent in the world, with 2.2 billion inhabitants—a quarter of the world's population. The continent contains a quarter of the world's land, 60 percent of all unused arable land, and a third of the world's natural resources. It is brimming with minable resources and energy, nine-tenths of which have not yet been exploited. Urbanization is growing: today about 45 percent of the population lives in cities, compared to the beginning of the twentieth century, when 95 percent of the population was rural. Since 2000, economic growth has been greater than 5 percent.[2] African nations are well represented among countries

2. Its GNP represents 4.5 percent of the global GNP in terms of purchasing

with the most elevated growth rates in the world from 2008 to 2013 (Sierra Leone, 9.4 percent; Rwanda, 8.4 percent; Ethiopia, 8.4 percent; Ghana, 8.1 percent; Mozambique, 7.6 percent).

Africans had to face a complex geography: an old continent, the heart of which is composed of vast, rocky plateaus of staggered erosions, where the altitude often surpasses two thousand meters; moreover, this heartland is mainly composed of a bedrock of ancient volcanic fractures (the Rift Valley). Its northern and southern extremities are characterized by Mediterranean climates; from the Equator, tropical forest gives way to savanna and desert. African peasants were able to adapt to diverse climate conditions and to adopt appropriate cultivation techniques: a polyculture of subsistence crops on the high plateaus; the adoption of grains when appropriate; tubers and legumes adapted to the environment;[3] lands left fallow and burned to the ground for regeneration; and the periodic migration of villages to conquer new lands.[4] The peasants were able to create flexible agricultural systems and adopt technological innovations adapted to their environmental conditions.[5]

power and equals around $2.2 trillion.

3. Corn and manioc are American plants more calorie-dense than sorghum. These American crops were introduced by the Portuguese in the fourteenth century. African peasants adopted them, and they progressively spread across the continent.

4. African soils are poor, apart from the Nile Valley and a few other strips of fertile volcanic land. In the savanna bordering the Sahel, where millet and sorghum are cultivated, the rainy season lasts for four months. In equatorial zones the rains are abundant, but the streaming water washes out the soil and strips it of mineral salts. Catherine Coquery-Vidrovitch, *Petite histoire de l'Afrique* (Paris: La Découverte, 2011).

5. Certain technological innovations appeared rather late in African agriculture. Mastery of iron allowed for the making of hoes. The wheel, although adopted in the Nile Valley, was adopted rather late in other regions of the continent. The wheel wasn't necessary given the abundance of land and the low population density, which allowed populations to reach an equilibrium between production and consumption.

A Bit of Historical Context . . .

In 146 B.C., as a result of the Third Punic War between Rome
and Carthage, Romans colonized North Africa. Roman Africa was
composed of Carthage (Tunisia), eastern Numidia, Tripolitania,
and Byzacena, which correspond to the western part of what is
now Libya. They made this fertile region of the Mediterranean
coast their breadbasket in order to feed the growing population
of the Roman Empire. They named these coastal provinces *Africa*,
after the Berber tribe, the *Afri*, who lived in the region. Arabs, who
invaded North Africa in the seventh century, Arabicized the name
Afri and called the coastal region of North Africa *Ifriqiya*. Euro-
pean navigators in the fifteenth century, who were exploring the
Atlantic coast of the continent in hopes of finding a maritime route
to the gold-rich land in West Africa, expanded the name *Africa* to
designate the whole continent.

The African continent has always been associated with an imag-
inary world of riches. The Bible evokes the country of Ophir, from
which came gold, precious stones, and sandalwood. The legend-
ary tale of the queen of Saba (whose kingdom was likely located
near Somalia) offering Solomon sumptuous gifts during her trip
to Jerusalem in the tenth century B.C. struck European imagina-
tions to such a degree that three thousand years later, European
adventurers were still searching for this land of gold on the African
continent.[6] Portuguese interest in Africa and its gold-rich land was
stimulated by the emperor of Mali, Kankan Moussa, who during
his trip to Mecca stopped in Cairo in 1324 and gave away so much
gold that, throughout the region and as far north as Constantino-
ple, prices plummeted for a period of ten years. To this very day,
Kankan Moussa is still considered the richest man the world has
ever known.

6. Martin Meredith, *The Fortunes of Africa* (London: Simon & Schuster,
2014).

Africa has been a place of commercial and cultural exchanges since ancient times. Africans have always traded among themselves and with other peoples. Paths, waterways, and transport routes across the Sahara and all of Africa permitted the trade of salt, iron, copper, slaves, and gold to many lands, including those of the Indian Ocean, Mesopotamia, and the Levant. Rich and lavish cities were built on the African continent in the Nile Valley, in Zimbabwe, and in West Africa. In Egypt people had mastered techniques for working with bronze since 3,000 B.C., and since the seventh century B.C. peoples in Nok, Ifé, and other places on the continent had mastered ironworking techniques. Civilizations were built, kingdoms were born and died. Large cities bordered hamlets of shepherds and nomads; social, political, and cultural transformations occurred in accordance with the dynamics of each place and time. Societies were judged by their capacities to pursue war and to integrate. Economic systems were aimed at ensuring individual subsistence, and organized the production and circulation of goods mainly from a foundation of social connections. The economy was inserted into the society.

Neither topics related to economic growth nor those related to trade balance come up in discussions of this era. Rather, history is perceived as cyclic or tragic, with periods of growth and decline. And this has been the case everywhere in the world: neither the Chinese civilization nor that of the European of the Middle Ages kept records of the wealth produced each year or of the evolution of their economies. Economic growth as a notion that guides and reflects the evolution of societies is recent in human history. It dates back to Europe's Industrial Revolution. The possibility of continuous progress in societies (knowledge and the accumulation of wealth and resources) appeared in the seventeenth century resulting from the Quarrel of the Ancients and the Moderns. Economic growth was one expression of this progress.

It would be a mistake to read the economic and social life of the continent through the prism of notions originating in

seventeenth- and eighteenth-century Europe. The driving force in African societies of the time was the desire to build lasting societies through colonizing lands, mastering the production of food, and triumphing over the perils of nature.

Demography and the Transatlantic Slave Trade

The struggle to increase the number of men and women has consequently always been a major characteristic of African history.[7] In the sixteenth century Africans had a demographic advantage. The population of Africa at that time was estimated at 100 million, 20 percent of the world population. Over the course of the next two centuries the slave trade greatly interrupted the population growth of West Africa. By the end of the nineteenth century the continent was estimated at representing less than 10 percent of the world population. The most conservative estimations indicate that 11,061,800 people were deported from the African continent via the Atlantic.[8] The highest estimations report 24 million people transported and anywhere between approximately 75 million and 200 million deaths related to capture, transportation, and various wars and razzias caused by the slave trade. The truth is, we may never know the exact number of deaths caused by the slave trade. The drop-off in the demographic growth in Africa appears to align precisely with the period during the eighteenth century marking the apogee of the slave trade's drain on Africa's population. However, we cannot reach a precise evaluation of the cost of the demographic draining due to transatlantic human trafficking by simply subtracting the number of those Africans who were deported from the African population at the time. Africa's population in the eighteenth century must be compared to what it would have become in the absence of the transatlantic slave trade. Using a model of

7. Iliffe, *Africans*, 275.

8. David Eltis, "The Volume and the Structure of Transatlantic Slave Trade: A Reassessment," *William and Mary Quarterly*, 3rd series, 58, no. 1 (2001): 44.

demographic processes, Patrick Manning[9] has estimated that the population of sub-Saharan Africa in 1850, in absence of the slave trade, should have been 100 million people. And yet, Africa's population at that time was, in reality, only around 50 million people, while China saw its population double in the eighteenth century, and Europe's population, after a brief stagnation in the seventeenth century, began to grow again as well. This growth was key during Europe's Industrial Revolution. As a result, Africa's portion of the world population (Europe, Africa, the Middle East, and the New World) fell from 30 percent to 10 percent between 1600 and 1900.

Transatlantic deportation also exposed Africa to new diseases: Europeans introduced tuberculosis, bacterial pneumonia, smallpox, and venereal syphilis. For a long time, sub-Saharan Africa was protected from the plague, but in the seventeenth century, epidemics of the plague began to spread throughout the Congo (present-day Angola) as well as the coasts of Senegal and Guinea around 1744. These same illnesses returned with colonization and after World War II, but Africans were better prepared and therefore more resilient. Added to all of this are the risks of a capricious climate. The continent experienced long cycles of drought with occasional respites, epidemics, and epizootic diseases (cattle plague). What would the continent have become without the transatlantic slave trade? We will never know.

Roots of the Present

The transatlantic slave trade (deportation) and colonialism were synonymous with the draining of wealth and resources as well as people, the destruction of societies, institutional distortions, the rape and pillaging of cultures, and finally the alienation of dominated societies into unscrupulous trajectories. According to Jan Vansina,[10] the European conquest of the Belgian Congo between

9. Patrick Manning, *Slavery and African Life* (Cambridge: Cambridge University Press, 1983).

10. Jan Vansina, *Les anciens royaumes de la savane: Les états des savanes*

1876 and 1920 resulted in the destruction of nearly half of the total population of the region. After a long period of denial or minimization of the impact that colonialism had on the economic trajectory of independent African nations, an abundant amount of literature dating from the early 2000s emerged in the field of economics[11] (Acemoglu, Robinson, et al.); this literature brought to light colonialism's negative impact on the development and growth of formerly dominated nations. Colonial heritage—measured in terms of the degree of economic penetration by the former colonial power and the subsequent dependence and shared institutional identity with this power by the previously dominated nations—is an explanatory component of African countries' weak economic performances. Institutional economics has largely documented the fact that institutions[12] have an impact on the economic and social progress of nations. Bad institutions can trap nations in a state of under-production and result in a weak level of the production of resources.

In their colonies, colonial powers created political institutions in the image of metropolitan powers. Spain transplanted feudal institutions that served to maintain and support aristocratic forms of power in Latin America, England decentralized institutions favoring competition, and France favored monopolistic institutions that were notably less protective of financial innovations. Through ever-increasing alterations to the processes and modes of accumulation and production (through economic and

méridionales de l'Afrique centrale, des origines à l'occupation coloniale, 2nd ed. (Kinshasa: Presses universitaires du Zaïre, Kinshasa, 1976), 183.

11. D. Acemoglu, S. Johnson, and J. A. Robinson, "The Colonial Origins of Comparative Development: An Empirical Investigation," American Economics Review 91, no. 5 (2001): 1369–1401; D. Acemoglu, S. Johnson, and J. A. Robinson, "Why Is Africa Poor?" Economic History of Developing Regions 25, no. 1 (2010): 21–50.

12. Institutions include rules of behavior, habits, conventions, and customs, but also ways of thinking, modeled by culture, religious beliefs, and practices; they determine and regulate human behavior.

institutional distortions), colonialism had a largely negative impact on the development of colonized countries. As Abdallah Zouache[13] notes, the most nefarious effects were generated by way of colonial models introduced by the Portuguese, Belgian, and French. .

The determining factors of each nation's economic performance are vast and varied. In addition to the factorial attributes of geography, human labor, and technology, history also plays a large role. To understand the role that history plays requires an evaluation of the channels through which historical shocks are transmitted. Thus, the economic performance of the various African nations are, in part, linked to the initial conditions bequeathed to them immediately following their independence from the former colonial powers. In the recent economic history of the continent, these conditions primarily manifested as the destructuring of economies (most notably through previous forms of production) and the relegation of African nations to a state of dependency by establishing trade and extraction economies, with the flimsy industrial fabric of extroverted economies—economies that lack diversification, export primary resources, and therefore are vulnerable to the volatility of their exchange rates.

A second reason for the weak performances of African economies is tied to poor economic management by the leaders of young, independent African nations who for the most part had made poor economic choices,[14] and to power relations that were and continue to be unfavorable to the continent as much in the international economic arena (international rules of business) as in the choices of the strategic options with regards to economic politics (an absence of autonomy in the choice of these options:

13. Abdallah Zouache, "De la question colonial chez les anciens et néo-institutionnalistes," *Revue d'Économie Politique* 124, no. 1 (January–February 2014): 129–49.

14. Under-adapted models of industrialization, bad structural and economic politics, unsustainable level of debt, absence of economic diversification, inadequate choice of primary specialization, wasteful management of public finances.

the structural modification programs, the consensus and post-consensus from Washington, Millennium Development Goals, etc.). In the end, the disadvantageous convergence of internal and external dynamics has led to economic performances that largely fall short of the continent's economic potential.

Hysteresis and Resilience

There are still important concerns surrounding the lasting effects of the shocks to the economic structures of African countries. Often a current discourse that would like to claim responsibility for laying the new groundwork in Africa is, to some degree, prone to self-flagellation and tries to completely deny the past consequences of the transatlantic slave trade and colonialism and their relation to the current trajectories of African countries. This type of discourse calls for these countries to take responsibility for their own economic situations and, above all, to assume the failures linked to the poor management of post-independence governance and to stop summoning the past and accusing others for justifying their own failures. These types of discourse are only partially justified.

Rulers of the post-independence era are responsible for managing resources and institutions and for dealing with the existing conditions. It was incumbent upon them to transform these conditions. Most of these rulers failed by making poor economic and political choices, some by pillaging the wealth of their countries for the benefit of their own clans, and thus many useful years for establishing the solid foundations of prosperous nations were lost. They are not, however, accountable for the initial conditions history bequeathed to them or for the unscrupulous dynamics inscribed within their inherited social trajectories. Simplifying things to the extreme and denying the impact of historical dynamics on the fate of peoples is a demonstration of ignorance or of intellectual bad faith. Shocks as significant as those reverberating from four centuries of the transatlantic slave trade and a century of colonialism

had major demographic, economic, political, and cultural conse-
quences; these shocks threw sand in the gears of the machine and
inflicted enormous costs on sub-Saharan African societies.

The effects of some of these shocks still persist today. Econo-
mists call the degree of persistence of the effects of a shock *hyster-
esis*. One of the issues at hand involves an assessment of hysteresis
and an understanding of the degree to which present-day African
economies are influenced by initial conditions. Were the condi-
tions put in place immediately following independence favorable
to political stability and economic recovery? The answer is a
resounding no. Moreover, added to these shocks were the effects of
the persistence of unfavorable conditions: formal independences
were conceded in exchange for the perpetuation of a system of
political, economic, and cultural dependence, all to maintain con-
trol over the resources of the African continent. The predation of
these resources still continues today through imbalanced contracts
and an unequal exchange to exploit Africa's natural resources. It
can be seen in the influx of illegal capital such as FDIs (Foreign
Direct Investments) and ODA (Official Development Assistance)
that leave the continent,[15] and in the economic re-colonization of
countries by former colonial powers (Ivory Coast, Senegal, Gabon,
etc.) whose large corporations (Bolloré, Total, Eiffage, Areva, etc.)
continue to comprise and manage the essential resources of the
private sector. And finally, it can be seen in the commercial bank-
ing spread throughout sub-Saharan Africa. Now, added to this has
been the arrival of Chinese economic penetration, whose pres-
ence has been deleterious for the continent: a bit of infrastructure
in exchange for the pillaging of Africa's natural resources and the
colonizing of its lands.

To call attention to these facts is neither a question of adopting
a form of fatalism nor refusing to face up to responsibilities. Nor

15. See Léonce Ndikumana and James K. Boyce, *Africa's Odious Debts: How
Foreign Loans and Capital Flight Bled a Continent* (London: Zed Books, 2012).

is pointing out that these *stylized facts* are part of the explanation of the African continent's present economic difficulties synonymous with obscuring the responsibility of bad post-independence governance and of the poor choices of African leaders. Rather, it is necessary to allow for the phenomenon to regain its historical density and complexity by calling attention to the noxious exogenous elements mentioned above, proceeding to a clinical examination, classifying the causes and evaluating their relative importance, and identifying among these the causes that persist today. The identification of the exact causes of illness is a prerequisite for finding a cure and healing. Once this work is done, the most urgent question is whether resilience and rebound are possible. It is this question that most concerns us; we must reflect on the conditions for regeneration. Throughout history, African peoples have exhibited great resilience and great endurance in the face of harrowing circumstances. The demographic vitality regained in barely a century is proof of this ardor. No dynamic system returns to its original state. The same can be said of societies. They can, however, regain balance and evolve toward a state that maximizes their chance for survival and growth.

It is this dynamic equilibrium that must be rediscovered. Initial conditions do not completely determine future conditions. The complex dynamic systems that we call societies have the property of equifinality: they can reach the same result coming from different initial conditions. For this reason, it is necessary to have demographic, economic, institutional, and psychic resilience.

As far as demography is concerned, the continent is on its way to regaining the advantage it had at the beginning of the sixteenth century. By 2050, Africa will represent a quarter of the world's population. A century ago it tallied 100 million people, of whom 95 percent were living in rural areas. A century later it tallied a billion people, of whom 45 percent were urbanites. In 2050 Africa's population will be 2.2 billion, 60 percent of whom will reside in urban areas. The demographic explosion during which Africa increased

its population tenfold in fifty years did not start until 1950. And by 2050, the largest quantity of the world's healthy and active population will be African. It is of the utmost importance then to carefully reflect on the challenges, in terms of human capital, posed by the transformation of this demographic dividend into a productive resource.

Economic resilience is a far more delicate undertaking. It requires a divorce from the models of production and accumulation inherited from the colonial period and a subsequent overhaul. This task is not, however, impossible, and other countries have succeeded in this economic transformation elsewhere. The main areas of economic growth today on the continent are a result of the extraction of oil and minable resources.[16] African economic growth mainly comes from such extractive industries and services. Regardless of the slight gains in currency that these extraction economies may generate, it is still imperative and vital to put an end to them. In the long term, such economies do not help to bring about a comprehensive development of countries; rather, they create environmental and social problems and corruption, and they bias intertemporal choices and the allocation of resources.

Due to an urgent need of currency to balance the public finances of their states, African leaders are often faced with the delicate question of whether to exploit their resources and natural wealth. In the short term, the focus of arbitration most often takes precedence in their strategic options, as it has an immediate impact on fiscal revenues and the financial resources of states having to face diverse needs, each as urgent as the next. These needs lead to accepting an absolutely imbalanced and unjust division of the wealth extracted from Africa's land; multinationals carve out for themselves the lion's share, under the pretext that they shared technology or developed resources that would otherwise not have been

16. Sylvie Brunel, *L'Afrique est-elle si bien partie?* (Auxerre: Science Humaines Éditions, 2014).

developed, while in reality it is the long-term investment choices that modify the structure of the economy and allow it to grow sustainably and in a balanced manner. The issue here is to escape the tyranny of urgent needs, to not sell off the resources of a continent rich in all kinds of reserves, especially since, as is the case with hydrocarbons, these reserves are made up of nonrenewable sources of energy that will eventually run out within a century.

An important element in solving this problem is allowing citizens to have control over mining contracts signed by the governments, as well as over the use of gains that come from them. The ultimate key lies in African politicians having a better transgenerational awareness and that there be a lasting record of their actions. We could imagine institutional apparatuses that delegate the management of natural resources of nations to institutions independent from the electoral cycle and from the regimes in place. Added to these issues is that of food security, which makes arable African lands a new object of desire. Foreign multinationals, with the complicity of nation-states, are trying to appropriate these lands in anticipation of the coming global need for an increase in agricultural production.

Questions of intertemporal arbitrage and of political and economic sovereignty also become of great interest and must be confronted head-on: the main responsibility falls on politicians. Here, it would help if African civil societies had a more extensive awareness of these challenges.

Reinforcing Improvements

Recent progress in terms of economic growth[17] indicates that, in many African countries, an upturn is now under way. One can observe this fact by the enormous amount of literature that analyzes and tries to take stock of this growth. The conclusions drawn by this literature are accurate, in part. Literature that recommends

17. Of the ten countries with double-digit growth rates, eight are African.

ways to accelerate growth dynamics in African countries, to make them stronger, more sustainable, and more inclusive, is also accurate in part, and on a certain number of these questions (not all) there is a consensus on what should be done. If this return of growth is to be transformed into a qualitative improvement in the lives of Africans, there must be vigorous public policies, investments in basic socioeconomic infrastructures, as well as strategic choices targeted at a structural transformation of African economies. It is absolutely necessary to remove the African continent's economic challenges and to adequately respond to the basic needs of the population by guaranteeing the conditions for a decent life. To do this, it is essential to make good use of the continent's productive capacities, to transform its resources and human capital into wealth, to equitably divide up this wealth and qualitatively transform African societies by raising the quality of life of the continent's populations and by extracting the necessary surplus to finance those practices that ensure the fundamental psychosocial functioning and psychological well-being of Africans, as well as the proper health of Africa's civilizational models.

Most economists agree on the need for an increased investment in human capital (education and healthcare) and infrastructure. They agree on the need for economic diversification and issues related to food security and the incorporation of technological innovation for an overall improvement in productivity. They agree on an increased cultivation of the comparative advantages already stemming from Africa's factorial endowments as well as an improvement in the quality of its institutions and economic governance. Countries that have opted for some of these solutions, such as Rwanda, Kenya, Cape Verde, Ghana, Ethiopia, Botswana, Uganda, and Mauritius Island, have seen excellent performance in terms of economic growth during the past decade. However, it is necessary to reinforce these improvements, to export the replicable aspects of these models to other African countries so as to deepen the range of ruptures and transformations in current

African economic practices in order to continue to structurally transform economies, to intensify investments in human capital, and above all to mobilize cultural dynamics and put them to work for the continent's economies; these are largely under-exploited and could serve as a form of economic and cultural leverage.

Thinking about African Economies in Their Cultural Substratum

A principal characteristic of the economic models in place for the past fifty years on the African continent is their foreign origin. These models are the result neither of African practices nor of an internal system of production. Hence the dualism of systems characterized by the coexistence of an economy dubbed formal with a popular economy based on a socioculture and dubbed informal that, nonetheless, ensures the livelihood of most of the African population and largely contributes to the GDP (54.2 percent in sub-Saharan Africa).[18] A primordial question that is not sufficiently addressed in the various analyses of African economies is the connection of these economies with their respective sociocultures. From a theoretical point of view, we cannot continue to be ignorant of the essential economic practices that allow Africans to ensure their subsistence for the sole reason that these practices come from an economy deemed to be informal, given that Africans' subsistence is the result of a relationship to the economic that has been honed and constituted by their own culture.

In traditional African societies,[19] economics was already included in a much larger social system. To be sure, economics conformed to its classical functions (subsistence, resource allocation, etc.), but it was, above all, subordinate to social, cultural, and

18. J. Charmes, "The Contribution of Informal Sector to GDP in Developing Countries: Assessment, Estimates, Methods, Orientations for the Future," *OECD EUROSTAT* State Statistical Committee of the Russian Federation, Non-Observed Economy Workshop, October 16–20, 2000, 14.

19. This analysis is confined to traditional sub-Saharan societies.

civilizational objectives. This is no longer the case in contemporary societies where the economic order tends to become hegemonic, overflowing its natural space and attempting to impose its meanings and logic on all dimensions of human existence.[20] Culture has an impact on perceptions, attitudes, consumer habits, investments and savings, individual and collective choices; it remains a principal determinant of the economic act. In human groups, imaginaries establish social relationships, even the most material ones. The economic act is first and foremost a social relationship. The imaginary and the symbolic determine its production. Cultural factors thus influence economic performances.

The first idea supported here is that the efficiency of an economic system is strongly tied to the degree to which it is consistent with its cultural context. African economies would see an explosion in growth if they were to operate in accordance with their own driving forces. The second idea is that we must go further than simply thinking of the effectiveness of African economics in terms of a better entrenchment within African cultures. It is above all a question of examining, in the African context, the articulation of these two orders, culture and economy, with a civilizational intention, one that would allow both the individuals and the groups involved to evaluate and confirm the goals judged as *the best*.[21] To accomplish this, it is necessary to consider the social project in its entirety by analyzing the multiple interactions of its environmental dimensions: those that aim to ensure the conditions for existence (the economy, ecology) and those whose goal is to work toward an understanding of the meaning of existence itself (culture, philosophies, orders of purpose). It is thus necessary to con-

20. Economics has become a discipline that has lost awareness of its place within the whole (anomie), that overflows its natural space and engulfs all social relationships by imposing its meanings and its logic of profit (private appropriation of nature, space, public goods, transformation of social relationships by the labor force).
21. The goals valued by that groups and individuals.

sider the place assigned within the social dynamic to the economic order. Moreover, our hypothesis is that an articulation of economic and cultural orders that avoids conflating their respective purposes will make societal projects more coherent.

Economy and Culture: Interactions and Reciprocal Formation

Economy and culture are powerful determinants of individual and collective actions. Economy is an order of efficiency concerned with the optimal allocation of resources. As a discipline, it has also become a space for reflecting on the theory of human action, and on what drives this action. Culture is defined by anthropologists as a group of practices and values, distinctive material and spiritual characteristics that identify a given social group. Culture is a polysemic notion,[22] used to convey a variety of meanings. Culture also includes all endeavors of the mind that require creativity in their production. These creative works are closely linked with the education of the mind, the production and communication of symbolic meanings (artistic, scientific, and literary culture, crafts, ways of life, and ways of inhabiting time). Because of this, culture is a space of perpetual creation, a way to grasp and explore reality in all its dimensions; culture is a moving object, in constant redefinition. It bears the dual dimensions of deed and process. Although culture can be a site for the creation of values, its purposes are, as a matter of priority, symbolic; these purposes come mainly from the production of meaning and significance.

22. A. L. Kroeber and Clyde Kluckhohn, with Wayne Untrereiner, *Culture: A Critical Review of Concepts and Definitions* (New York: Vintage Books, 1952). Kroeber and Kluckhohn took inventory of more than 164 definitions of culture. According to the cultural anthropologist Edward B. Tylor, "Culture or Civilization, taken in its wide ethnographic sense, is that complex whole which includes knowledge, belief, arts, morals, law, custom, and any other capabilities and habits acquired by man as a member of the society." Tylor, *Primitive Culture: Researches into the Development of Mythology, Philosophy, Religion, Art, and Custom* (London: John Murray, 1871), 1.

The Cultural Foundations of Economic Choices

An individual's decision-making processes are strongly influenced by his cultural environment, which conditions his preferences and regulates his behavior. The satisfaction of basic needs such as food, shelter, and clothing . . . results in choices that are not solely dictated by existing alternatives, that is, by the quantity of goods and services available to satisfy these needs. An individual's cultural matrix—composed of social conventions, religious beliefs (food prohibitions, dress codes), culinary traditions, notions of beauty, ethical prescriptions—has the function of shaping his desires (needs) as well as the circumstances (temporality, place) of their satisfaction. The temporality of a need's satisfaction, or even that of the transformation of a need into a desire—that is, a need for which satisfaction involves the mediation of labor and time—is conditioned by culture. Moreover, the structure of what are considered basic needs evolves, and certain needs, while culturally induced (television, cigarettes, mobile phones, the internet, cultural needs, entertainment), become no less fundamental to individuals.

Economic anthropology observes that saving, investment, and earning behaviors, as well as the logics and rationalities that preside over certain patterns of consumption, are culturally determined. Herskovits[23] emphasizes that certain West African peoples (the Yoruba) used up their food reserves ceremoniously and liberally between the end of the dry season and the beginning of winter. We would have expected these peoples to save food in preparation for the upcoming period of shortage. These behaviors were not, however, attributable to an absence of foresight on the part of these communities; rather, these behaviors are dictated by cultural considerations that valorize spending linked to rituals, ostentatious

23. Melville J. Herskovits, *Economic Anthropology: A Study in Comparative Economics* (New York: Knopf, 1952).

spending, and spending for prestige and that inscribe the act of consuming with significations beyond that of the biological necessity of nourishment and provision of the calories required for physical labor. Economists have made the same observation of the Tallensi of the Gold Coast (present-day Ghana), where the food supply is lowest at the time when, due to physical work in the fields (May and June), the people need the largest number of calories; yet the Tallensi, have mastered stockpiling techniques. For the Zulu, Ashanti, Baluba, and Baganda peoples, prestige economy plays an equally important role in the maintenance of an individual's social status. Customs require that hosts serve quality food to guests, even if what they themselves eat in private is of lesser quality.

When we examine the analysis of family and individual budgets and the allocation of resources, we find, for example, that in the Igbo families of northern Nigeria larger sums are allocated to symbolic goods (spending for religious purposes, funerals) than to tangible items. There certainly is a universal propensity to satisfy nutritional needs as well as personal tastes, but for the Igbo, religious and social obligations are as important to the life of the group as is food for the body.

What's more, different conceptions of household economic management did not come about by happenstance; rather, they are the results of different modalities of the social evaluation of time, work, leisure, and social and religious obligations. Hinged on the quantity of available resources, these terms define a community's productivity and quality of life.

The preceding reflection relates to traditional societies whose social and behavioral structures reveal a stability and sustainability that allow such an analysis. Two dominant and distinctive traits emerge from this analysis: there is, of course, a utilitarian method of consumption at work, but one which is first and foremost, a practice of the symbolic consumption of material goods, leading to the second trait which is that of a mentality and practice of sharing

anchored in the cultural substratum of traditional communities. The individual belongs to a group and to a historically rooted social formation. To a large degree, social interactions established through group culture explain an individual's economic choices.

Economy as a Cultural Process

Economics as a scientific discipline and as a field of knowledge is the result of a process that can be qualified as cultural. The different schools of thought that comprise the field of economics are characterized by a group of practices and beliefs that form them. Just as shared values create the foundation of a group's cultural identity, in the arena of intellectual economic discourse it is possible to interpret the coalescence of Marxist, Keynesian, neoclassic, neo-institutional, and other schools of thought as cultural processes.[24] Moreover, the impact of culture on the thinking of economists is significant. The cultural values they inherit or acquire have a profound and often unknown influence on their perceptions and attitudes. Thus, economists' inherited cultural presuppositions influence their ability to explain the economic reality they observe, even more so when this reality is different from their own.[25] An economy's cultural context comes from both a social organization and a system of thought. Therefore it appears that the dominant economic thought conveys a culture, a unique view of the world and of man (*homo economicus*). Cultural considerations thus affect how economists practice their discipline, develop their assumptions, and model interactions between agents. Economic thought develops a collection of beliefs and values that it protects and promotes.

24. David Throsby, *Economics and Culture* (Cambridge: Cambridge University Press, 2001).
25. Dudley Seers, "The Limitations of the Special Case," *Bulletin of the Oxford Institute of Economics and Statistics* 25 (1963): 77–98. Looking at historical and empirical facts, Seers contests the dominant economy's claim to universal validity.

Throsby,[26] who analyzed the procedures through which economic ideas are produced, discussed, approved, and transmitted, notes that these procedures belong to a type of discourse such as the one analyzed by Foucault. The research community's acceptance of these procedures is based more on processes of legitimization and intellectual persuasion than on an accurate translation of an observed reality.[27] In this context, economic discourse functions as a language that ensures the establishment of a common symbolic code through which the group's ability to name, think, and experience the real develops. Economic discourse defines the linkages between facts and concepts, distinguishes the necessary from the ancillary, and selects materials from the real that this discourse makes available to construct a group's ability to name, think, and experience the real. This language is not neutral, for it creates a structuring of space and time, choosing to shine a light on certain aspects while leaving others in the dark, thereby establishing a hierarchy of values and shaping modes of thought and action.

The Value of Things

Economic thought produces culture in that it disseminates and promotes, within the social body, practices and ways of doing things. It also projects its own evaluation criteria onto all human activities, including those whose primary function is not part of the trade market. Economy and culture as spaces of human thought and action have always been concerned with the question of the "value" of things. The adequate evaluation of a good's value is central to an economy. Since the eighteenth century, different conceptions of a good's value have competed in theoretic discourses.[28]

26. Throsby, *Economics and Culture*.

27. The efficacy of competitive markets, the fact that they are in pure and perfect competition and in equilibrium, comes more from a belief in a paradigm than from observation of a reality in which the position of the observer influences the perception of the observed phenomenon.

28. Already in the eighteenth century, Smith distinguished between a good's use value and its exchange value. Nineteenth-century economists (Ricardo,

Debates about value within the economic paradigm link it with the notion of utility, or with the price that individuals and markets assign to goods. In the cultural sphere, value involves an intrinsic property of certain objects or cultural phenomena and can be expressed as the quality of a work (a literary masterpiece, a sculpture, a painting, a piece of music) or of an experience. Value is a social construction that cannot be evaluated outside of the context of its production. The notion of value is often attached to the uniqueness of an object or a work imbued with meaning beyond its practical utility or its materiality.

The quality of one of Richard Bona's musical compositions[29] or of a novel by Ayi Kwei Armah or Boubacar Boris Diop stems from the unique dimension and sensitivity of the existential experience translated and transmitted through these works. Adorno and Horkheimer,[30] as well as Arendt,[31] point out that by applying the logic of economic practice to cultural objects, the culture industry[32] leads to the degradation of all cultural objects into ephemeral consumables and results in the production of a culture of leisure

Marx) determined the value of a good by the cost of its fabrication: the quantity of necessary inputs for its production and the quantity of work necessary to make it. After the Marginal Revolution, economists viewed prices as the way the market coordinates the different assessments of the actors in the economic system, and neoclassical analysis equated price theory to a value theory.

29. Richard Bona is a famous Cameroonian musician, bass player, and author-composer-performer who created a beautiful synthesis of traditional Cameroonian music and jazz. Currently, he leads a large international music career.

30. Max Horkheimer and Theodor W. Adorno, *Dialectic of Enlightenment: Philosophical Fragments,* ed. Gunzelin Schmid Noerr and trans. Edmund Jephcott (Stanford: Stanford University Press, 2007).

31. Hannah Arendt, *Between Past and Future: Six Exercises in Political Thought* (New York: Viking Press, 1961).

32. The notion of the culture industry was forged by Theodor Adorno and Max Horkheimer of the Frankfurt School. They affirm that the mass distribution of culture is dangerous for artistic creation. The culture industry (cinema, radio, free press, television) does not tend toward individual emancipation, but the complete opposite: a standardization of the individual modes of living and toward the domination of economic logic.

created to fulfill the needs of its economy. The commodities that the leisure industry offers are not cultural objects in the true sense of the term, as defined by Arendt, meaning objects whose function is to support and enrich life, to establish continuity and duration (functions that transcend needs), to be traces of our human adventure meant to remain in the world after we have left it; rather, these commodities of the leisure industry are considered as consumable goods to be used and replaced by others through a cycle of production that ensures the continuity of an industry that requires continuous production in order to remain in existence. Moreover, a culture of material production, of optimization, of production at the lowest cost, of transactions mainly based on market trade and exclusion through cost, as well as the equation of notions of value and price—such a culture, applied to all spheres of social life, could bring about a destruction of value and a perversion of the purpose of objects.

Anchoring African Economies in Their Cultural Context

Despite the upheavals of a turbulent recent history, if there is a space where the potential for the dissemination of Africa's brilliance remains completely intact, it is that of culture. This order could constitute the foundation of a more efficient economy, because it would be better connected to its cultural context. This desire for a connection between the economy and culture nevertheless presents a number of difficulties. Many cultural regimes exist in African societies: a popular culture that seems opposed to an elite culture based mainly on imitations of foreign models of consumption; an urban culture of *globalized* youth that consumes global mass subculture (hit songs, video clips, etc.) as well as simultaneously consuming a culture considered traditional. There are also power relationships within groups that frequently result in the imposition of a dominant culture by the elite. However, for many people, culture is a palimpsest composed of different, superimposed layers, borrowing from a universe of diverse references.

If we consider that culture is a transactional concept in constant redefinition, a dynamic notion constantly being renegotiated, the difficulty becomes identifying the distinctive and stable traits that could be considered as the framing structure of the core personality of groups and communities. However, although there is neither an immutable essence nor an unalterable identity, it seems that this core personality of communities does exist, that it evolves, but does so slowly. The Béti in Cameroon, the Sérères in Senegal, and the Sonrai in Mali have practices and customs, references and values in common, a way of understanding relationships with others, and these cultural traits influence their relationship with the economy.

Furthermore, Cheikh Anta Diop[33] revealed the existence of cultural unity between peoples who shared in large sociohistorical formations over time (ancient Egypt, the empires of Ghana and Mali; the Mediterranean, Tripolitan, and Cyrenaican regions). It is therefore possible to emphasize that in contemporary African societies, despite the dilution of a tradition's capacity to regulate behavior, certain traits of traditional culture persist, notably, those tied to prestige expenditures, to investment in symbolic goods, to the injunction of generosity, and to the interiorized notion of a duty to assist. This latter notion could explain in part the large amounts of money that migrants transfer to sub-Saharan Africa, which, for most of the countries, exceeds public development aid and sometimes even exceeds direct foreign investments (which could also be examined using the logic of gifts and counter-gifts). These surviving traces of traditional culture, however, face competition from utilitarian and individualist logics that impose the transformation of social relationships induced by social modernity that has now made individual success the driving force of the social adventure. However, a closer observation of the behavior of economic agents reveals that self-interest-motivated rationality

33. Cheikh Anta Diop, *L'unité culturelle de l'Afrique noire* (Paris: Présence Africaine, 1959).

does not always prevail in their decisions. *Homo africanus* is not a *homo economicus* in a strict sense. Decisions, rather, are to some degree motivated by logics of honor, of redistribution,[34] of subsistence, of gifts and counter-gifts. There are multiple activities outside of the market or within the frame of primary sociability (families, personal connections) or the frame of secondary sociability (social system or the reign of an injunction of generosity). However, despite the various mutations under way, the cultural context of contemporary African societies, although compound and borrowing from various universes of reference, constantly renegotiating and reevaluating its values, remains a powerful determiner of the economic choices of its members.

From a theoretical point of view, a better foundation of the economic on the sociocultural involves, first, a better understanding and analysis of the determining factors of the individual and collective choices of the societies in question by applying an appropriate conceptual apparatus. A detailed understanding of these factors is a prerequisite for any policy aiming to improve the standards of living of these groups.

To do this it is first and foremost necessary to address the dominant economy's deficit in the realm of theory. The analytical frameworks based solely on the premise of methodological individualism[35] fail to take into consideration the factors that determine the economic behaviors of *Homo africanus*. The above examples bring us to doubt the explicative capacity of this premise as the basis for the choices of people within African societies. The formal analyses made by the dominant, mainstream economy minimized the impact of a people's culture by thinking of their

34. In Africa, generally speaking, not only does a salary benefit the wage earner and his immediate family (wife and children), but a significant portion of his income is also redistributed to close relatives (fathers, mothers, siblings, aunts, uncles, grandparents).

35. Methodological individualism comes from the idea that, to understand behaviors within a group, it is necessary to begin with individual motivations, that this individualism is the basis of societal function.

behaviors in terms of manifestations of universal characteristics that could be fully subsumed within the rational model of individual utility maximization, independent from cultural and historical contexts.[36] Behavioral economy reveals that even though agents react to incentives and changes in the price of goods, they do not always base their decisions on cost-benefit calculations. Thus a better understanding of the bases of their behaviors—their psychology, their culture, and their social realities—would make economic policies more efficient.[37]

We must mend the holes in the neoclassic paradigm by also including holistic and systemic approaches; by considering collective strengths, socially built institutions, and historic structures of social formations; and by identifying other methods of regulating production that account for collective choices influenced by the culture, not just for individual preferences. Exploration of works in the fields of economic anthropology, socioeconomy, history, political science, psychology, and institutional economy could help in thinking about the concept of the economy as part of a larger social and natural system. This is a theoretical challenge: it requires the production of an economic discourse that grasps the roots of observed economic practices.

Avoiding the Conflation of Orders

The second challenge consists in improving how we consider and reflect upon what individuals and groups target and value as their the ultimate goals, across all mechanisms of social exchange, and

36. Even when the mainstream economy attempts to capture these effect, it does so using its own terms. Guido Cozzi interprets culture as social capital that enters into the function of classical production". Cozzi, "Culture as a Bubble," *Journal of Political Economy* 106, no. 2 (1998): 376–94.

37. See World Bank Group, *World Development Report 2015 : Mind, Society, and Behavior,* http://documents.worldbank.org/curated/en/6457414683395 41646/pdf/928630WDR0978100Box385358B00PUBLIC0.pdf{~?~URL: http://documents.worldbank.org/curated/en/645741468339541646/ pdf/928630WDR0978100Box385358B00PUBLIC0.pdf}.

to assign to these goals, through a principle of efficiency, the appropriate instruments for their achievement. Via this perspective, culture would be tasked with defining the goals that individuals and groups value, and economics, as a discipline, would have the function of exploring ways to allocate resources to attain these goals. Thus, economics would give up its hegemonic tendency of shaping all social practices and would once again become an order of means subordinate to the ends valued by individuals and groups.

The economies of traditional African societies were marked by the fact that the production, distribution, and possession of goods was regulated by a social ethics, the goal of which was to guarantee everyone's livelihood through the redistribution of resources and the right of each member of the community to receive help from the whole society if the need arose. The division of labor involved the group's entire vital force, fulfilling the function of integrating all people in the society and assigning to everyone a role in its functioning. This flowed from a certain concept of the collective's well-being and from an economy at the service of the community.[38] These economic systems have been planned and subverted by the capitalist economy, which is largely focused on individual profit, having forgotten its original functions.[39]

In the seventeenth century in the West, philosophers, legal experts, and economists were interested in measuring social well-being, in exploring its variables and in maximizing it (Jeremy Bentham, John Stuart Mill, John Rawls, Amartya Kumar Sen, Martha Nussbaum).[40] An economics of well-being aims to maximize well-

38. Georges Ngango, *Éthiopiques* (November 1976), in a special volume of the black African socialist revue for the celebration of the seventieth birthday of the first Senegalese president, Léopold S. Senghor.

39. New demands of inclusive growth seem to be leading the economy back to wanting to reestablish its original functions: responding to the needs of individuals.

40. Jeremy Bentham, *Théorie des peines et des recompenses*, trans. Etienne Dumont (Paris: Bossanges Frères Libraries, 1925); John Stuart Mill, *Utilitarianism* (London: Longmans, Green, Reader & Dryer, 1871); John Rawls, *Theory*

being for the largest number of people. Bentham and Mill based this on the concept of utility. The economics of well-being involves maximizing individual and social utility, revenue being one of its main indications. Sen carried out a critique on the limits of an exclusively utilitarian vision of well-being, based mainly on revenue, by proposing an approach based on capabilities. Capabilities[41] define the freedom or ability to be and to do what one values; this is a theoretical framework based on real liberties. In other words, the evaluation of well-being focuses not only on livelihood, such as revenue,[42] but also on the real possibilities for individuals to live and to choose. Social well-being involves pursuing the opportunity to lead a good life in accordance with one's criteria of evaluation. For example, *health* is a capability, and *being in good health* is a functioning result of this. It is necessary to have factors of conversion to go from capability (health) to a proper functioning (being in good health). Nussbaum[43] encourages reflection on public policies and their evaluation through her recommendation of a care economy that would succeed in taking care of each person's idio-

of Justice (Cambridge: Belknap, 1971); Amartya Kumar Sen, *L'idée de la justice,* 2nd ed. (Paris : Flammarion, 2012); Martha Nussbaum, *Women and Human Development: The Capabilities Approach* (Cambridge: Cambridge University Press, 2000).

41. The basic concepts in the capabilities approach are functionings and capabilities. Functionings are accomplishments or achievements in terms of actions or states. They can be very basic in nature—being in good health is a functioning (health is a capability); having enough to eat; being safe from risks of premature death, etc.—or very complex—being happy; taking part in community life; maintaining dignity, etc. (Sen, *L'idée de la justice,* 76). More than states or action, capabilities define the freedom or ability to be and to do what one values and what one has a right to value. A central element in the definition of capabilities is freedom, in its positive sense, meaning the possibility a person has to lead a good life.

42. Poverty and inequalities remain the goals of economic policy, but it must also go beyond to recognize the multidirectional nature of the notion of well-being.

43. The choice of capabilities could be based on an existing, predefined list, such as Nussbaum's in *Women and Human Development.*

syncratic (particular) needs and preferences by offering a space in which they can be met.

Sen's and Nussbaum's approaches interest us because they make it possible to avoid the pitfall of economism and to reintegrate economy into a larger social system. Moreover, the vision of well-being understood as the possibility to lead a good life in accordance with one's own criteria of evaluation makes it possible to avoid projecting mythemes from other contexts onto groups or individuals. Furthermore, public policies would be assigned with promoting the psychosocial functioning of groups.

The question of how to define which dimensions to valorize in order to improve the well-being of individuals can, nonetheless, present a problem. Nussbaum reckons that it is necessary to begin from a predefined list of functionings, whereas Sen, on the other hand, thinks that this list must be unique to the context and determined by public reasoning.

One solution could involve defining a minimum ethical standard shared by all with agreed-upon goals—education, health, nutrition, fundamental rights—and then establishing lists of desired functionings by formulating normative hypotheses based on a society's values as reflected by current social or religious theories. For example, it seems important for the well-being, equilibrium, and cohesion of a group—for example, members of a Sufi brotherhood—to dedicate a whole day of the week to religious ceremonies or to devotion, and the idea of evaluating this non-working day exclusively in terms of a loss of productivity or of economic loss would be partial and would fail to consider the fact that by taking care of a psychosocial function of this group, the subjective well-being of its members increases.

To avoid the pitfalls of a group's dominant ideologies, a second method could involve engaging in a debate during which individuals deliberate on the dimensions of their lives that they consider meaningful. This approach seems more fruitful. Finally, it would be possible to develop a group of dimensions that represent people's

values based on empirical evidence gathered by analyzing behavioral data or individual beliefs.

With the goal of deciphering the forces driving economic action, anthropologists, sociologists, and researchers in social sciences and humanities[44] interested in the African continent have pointed out that in this geographical area, objects, as well as goods and services, circulate in a relational economy that favors interpersonal and intercommunity[45] relationships. This economy, which Maurice Obadia[46] calls a relational economy, seems to be the most powerful determinant of trade and of the framework of the material economy. This explicatory schema, although in need of more empirical support, merits reflection.

Obadia defines relational economies as based on the production and trade of authentic relationships. This relational economy precedes the material economy. A relationship is the connection that individuals voluntarily establish between themselves. They may form this connection through specific material structures, independently of the market value of these structures (e.g., the attachment or aversion that a person could have for an object, a being, a place). The entire range of positive or negative relationships that individuals can build between each other, produce, trade, sustain through time outside of any truly material consideration or thought constitutes the substratum of a relational economy. An internal and external relational fabric, thus constituted, takes on a quality and a strength such that it constitutes value in and of itself. Not requiring the presence of material to exist, it can function outside of the determining factors of classical economics. Money can be a consequence, but it is not the objective. This relational economy could be at the root of a collective intelligence at the heart of

44. Herskovits, *Economic Anthropology.*

45. The widespread tontine practices and gift economies seem to support this interpretation.

46. Maurice Obadia, "Économie relationnelle et économie matérielle," *Les Cahiers du Sol,* no. 9 (2012).

a community (a group, an enterprise, a peasant cooperative), and it could create added value. Moreover, any creation of wealth requires interaction with this economy. Material and relational economies can be mutually beneficial if each keeps in mind that neither is the target of the other and that each recognizes its respective territory and rules of operation. Furthermore, the aim of a relational economy is to produce quality relationships between individuals,[47] relationships that constitute values in themselves.

The example of the Mourides in Senegal illustrates the connections between the relational economy and the material economy. The first appears to be the framework of the second. The Mourides are a Sufi brotherhood from Senegal whose founder, Cheikh Ahmadou Bamba (1853–1927), led a peaceful cultural resistance to colonization, drawing on Islamic values reinterpreted by black African cultures. Within this community there is a work culture that some have compared to the Protestant ethic that Max Weber[48] analyzed. This community's work culture is based on a *hadith* (saying) of the prophet Muhammad taken up by the brotherhood's spiritual leader, "Work for this life as if you were to live eternally and for the beyond as if you were to die tomorrow," and on the various recommendations from the founder of the brotherhood that appear in his sermons/poems: "I recommend two things to you and do not associate them with a third: these are work and the worship of God. This is how you will achieve peace . . ."

There exists in this community a culture of work and effort, certainly, but also one of engagement, of self-giving, and of obedience

47. The production of a relationship worthy of this name involves rare, limited, and depletable factors: energy and information over a specified period. These are the same factors as in the production of material things, which also require raw materials and capital. However, it is costlier to produce a quality relationship, as it requires energy, time, and diversified information over a significant period.

48. Max Weber, *The Protestant Ethic and the "Spirit" of Capitalism, and Other Writings*, ed. and trans. Peter Baehr and Gordon C. Wells (New York: Penguin, 2002).

to the *ndigëls*, which are dictates of the community's spiritual leader. This leader can mobilize a large, free labor force for different jobs that serve community interests, for example, preparing forty-five thousand hectares of forest for agricultural production. Thus, most economic interactions are based in the connections that unite members of this brotherhood. Here we are provided with an example of a flourishing material economy whose main determiner is the relational economy. This relational economy is characterized by the existence of a solidarity within the brotherhood that allows for basic economic needs to be met at a minimized transaction cost, relationships being based in confidence and respect for verbal commitments. Among the members of this community we find a system for transferring compensatory funds for when community members embark on business trips, thus allowing them to avoid the costs of the classic banking system; an establishment of economic networks and of solidarities; and a tradition of making free capital available to launch an economic activity as well as methods of reimbursement. Mouride merchants occupy the main sector of Senegal's informal economy, notably in trade, construction, textiles, and processing. Their social and economic success is explained by a common ideal and a strong feeling of belonging to a community. This popular economy based on sociocultural and religious values shared by a group is dynamic and allows the Mourides to control significant sections of that what is called Senegal's informal economy,[49] which employs 60 percent of the active population and represents 54.4 percent of the GNP. The city of Touba, seat of the brotherhood, is the second-largest city in Senegal due to its demographic and economic weight.

49. Thiam El hadji Ibrahima Sahko notes that, until the 1970s, the Mouride brotherhood was considered part of the theocratic agrarian movement due to their significant peanut production. In the early 1980s the Mourides invested in the small business; today they have surpassed wholesale trade and have reached an industrial and entrepreneurial level. See Thiam El hadji Ibrahima Sahko, "Les aspects du mouridisme au Sénégal" (PhD thesis, Université de Siegen, 2010).

In the preceding example, it is a question of preserving the founding principles of this relational economy and of avoiding transferring onto it mechanisms from the classical conceptions of the economy. According to Obadia, the culture of the classical economy can negatively influence the relational economy and result, for those who measure their relational production by minimum cost, in the construction of a negative relational economy.[50]

A fruitful articulation between economy and culture will come from a better anchoring of African economies in the dynamic values of their sociocultures. This can only be done by limiting the omnipotence of the economy, by forcing it to strictly adhere to its functions and to the role of its order: the exploration of the knowledge and know-how linked with the allocation of resources and the production of economic goods. Thus, in entrusting culture with the production of values and meaning, culture becomes the source of regulatory myths and the organizers of the social adventure. The capacity to reappropriate one's future, to invent one's own teleologies, to organize one's values, to find a harmonious equilibrium between different dimensions of existence, will depend on the capacity of African cultures to conceive of themselves as projects encompassing the present and the future and having as a goal the promotion of freedom in all its expressions.[51] From this perspective, a fruitful articulation between economy and culture will only come about through the alignment of each order with the specific goal that it can most efficiently achieve.

50. A positive relational economy requires not only a certain quantity of energy but also a specific quality of energy along with a diversification of information.

51. Valentin-Yves Mudimbé, *L'odeur de père* (Paris: Présence Africaine, 1982).

4

Healing Oneself, Naming Oneself

The economic, political, and cultural spheres are pillars of the social structure that must be renovated and rebuilt. The psychological sphere is the fourth of these pillars and not the least fundamental of them. Centuries of alienation and subjugation have left their marks on the personality and psyche of the African being. The African being must heal himself of the narcissistic and psychological wounds that have been inflicted upon him and that, today, are expressed by way of a lack of self-esteem, amounting to an interiorized inferiority complex for some and, for others, an abysmal lack of self-confidence. Fanon's description of this alienated consciousness[1] still captures reality and current events. We can still bear witness to a troubled relationship with others, mainly with the former colonist, who struggles to place himself within a relationship of horizontality and reciprocity. There is still a tendency to deem whatever may come from the West as being better—and this is the case regardless of the domain—in terms of expertise, quality, and judgment. There seems to be a pathological decentering, a lack or absence of selfhood that translates into an inability to think for oneself, to judge and evaluate things on one's own. Added to this complicated problematic, we see an external relationship to things. Popular expressions in West Africa, such as the saying *White man's science,* used for speaking about scientific

1. Frantz Fanon, *Black Skin, White Masks,* trans. Richard Philcox (New York: Grove Press, 2008).

knowledge or its technical application, are indications of the current self-exclusion of certain individuals from the common scientific tradition. This scientific heritage would appear to be the domain of others, notably of this white witch doctor, considered as a master of *techne* having stolen from the gods a secret inaccessible to mortals. In spite of the fact that the archaeology of knowledge has demonstrated that humanity's scientific heritage was a collective construction with moments of revolution determined by specific sociohistorical conditions, through the contributions of all forms of human intelligence and all peoples at moments in history, for the majority of Africans a feeling of foreignness still remains.

In the area of scientific cooperation, a Western-centric bias very often leads African governments to privilege foreign expertise,[2] even in areas where local expertise is better. This tendency is found at all levels of social organization, perpetuating the myth of the so-called white Western expert who arrives on the continent to provide the better way of doing things. In soccer the little white witch doctors are legion and train most of the African teams. Struggling to find work at home, they come to coach on the African continent and are sometimes paid a higher salary than sitting presidents of the French Republic. This alienation can also be read in the frantic desire of some intellectual and artistic elites to be christened and sanctified through recognition from Western authorities— academies, literary and artistic prizes, university degrees, and so forth. This acknowledgment is seen as the only recognition that matters. Unfortunately, this kind of sentiment is often shared by the masses. Often someone with a specific talent is not locally recognized until he or she has been recognized by the authorities of Western legitimization. Whatever the domain may be in which intelligence, talent, and genius are expressed under our skies, it

2. It often happens that this person has the work done through subcontracting to the local experts once the contract is established. Most strategic plans, raised from the economic perspective of sub-Saharan states, were devised by the same Western consulting offices, despite rich local expertise on the subject.

must make a detour by way of the place where the sun sets, in the West, to be recognized there.

We are now slowly beginning to see the emergence of the fundamental question of how to win back our self-esteem and to reconstruct our own psychological infrastructures. What are the conditions for regeneration? How does one heal one's ailing ego so that one's *élan vital* can bloom? How does one free oneself from self-hatred and rebuild one's self-esteem? What is the proper course of treatment? Must old ways be restored or a new world created? What are the necessary foundations that will help us to envision a new creative force?

Psychoanalysis teaches us that neuroses can be not only individual but also collective, and transmitted transgenerationally. For Heidegger, connecting with one's being is the necessary condition for changing the situation of mortals. For Achille Mbembé, music, religion, and writing are examples of such potential remedies: they become the sites for analytical practices that can lead to an *increase of humanity*.[3] Certainly, since music and religion are established arts of participation, they play an important role in this process by offering up possibilities for communion, catharsis, and the transformation of a group into an activity (a society is only effective when it becomes an activity: through engaging in its collective capacity for acting in common).

The Demand for Dignity

On June 20, 2013, a thirty-year-old Senegalese woman by the name of Bousso Dramé, after having obtained a visa for France, refused it, explaining her reasons in a letter addressed to the French ambassador. Her main reasons for refusing the visa stemmed from the lack of respect shown to her by the civil servants at the French embassy. This event had a significant impact. It was widely discussed in the

3. Mbembé, *Out of the Dark Night: Essays in Decolonialization*

national and even continental press, creating a long-lasting effect and buzz in social media. A young African woman who says, No thank you, I will not go to your country because I demand respect in the manner in which you invite me, was most unusual. Was it a sign of the times? A demythification of the western El Dorado? Unabashed pleas for respect by a youth of a new generation that no longer accepted the remnants of the colonial relationship? This projected image is in stark contrast with the daily images of the clandestine emigrants who risk their lives in the boats of fortune that have sadly transformed the Mediterranean into a giant cemetery for African migrants.[4] There were a large number of others who, following Dramé, attested to the humiliating treatment inflicted upon them by the French embassy at the time of their visa application: common occurrences known to all Africans. This letter forced the French ambassador to respond, to justify himself, and it was noted that afterward there was an improved reception of visa applicants, probably as a result of internal instructions. Some noted that Bousso Dramé, educated in the world's best universities, had the intellectual means to revolt. What is significant about this event was its barometric reading of a certain segment of the population of African youth. Educated by their cultures and shaped by modern knowledge the same way as everyone else,[5] and more specifically, no longer clinging onto any kind of colonial complex, this younger generation demands from now on to be respected

4. Clandestine emigrants impose on the world their right to a better life: by refusing the status quo, they jostle the geopolitical order that is unfavorable to them and thus contribute to moving the lines. But above all, they perpetuate a practice as old as humanity: emigration as an aspiration for a better quality of life. This is the foundation of the entire history of human migration.

5. This younger generation of Africans, as a result of the difficulty of obtaining a visa for Europe, has turned away from the face-off with the West by going to study and train everywhere else in the world: Southeast Asia, North America, Turkey, China. Among the fringe educated in their own value system, a demand for respect rooted in self-consciousness can also be read.

and no longer wants to be part of the pathological relationship their elders maintained with respect to the former colonists and colonial powers.

This segment of the younger generation spends a large amount of its time on social media; they maintain blogs, tweet, and comment on current affairs, expressing their opinions and watching the progress of the world. They are quick to react against *la francophonie* when the latter dons the clothes of cultural imperialism, in spite of the demographic and sociolinguistic dynamics that make French not simply one African language among many but a language that will only survive and maintain its position as an international language with the help of the French-speaking populations of the African continent. This same youth rebels against the symbolism of Françafrique summits, where the heads of state of the African continent are summoned to the French presidential palace, the Élysée, like primary school children in need of a lesson from the teacher. On the presidium we see the current French president alongside the African heads of state, we see the figure of a continental economic power and his good students in the subject of democracy and most importantly the best proconsuls: those who shed more tears than those of a bereaved prince. The fundamental asymmetry is already evident by way of the simple fact that a single country summons an entire continent to show it the steps to take and how to solve its problems. During the Françafrique summit at the Élysée in 2013, François Hollande asked Africans to create a rapid response force in order to address their security problems so that, implicitly, France would no longer be obliged to come help resolve certain problems in their place, even if we are well aware of the fact that these interventions, under the guise of humanitarian reasons, serve the geostrategic interests of this former colonial power.[6] This is this lunar reality, with its reflection

6. For more about this see Aminata Dramane Traoré and Boubacar Boris Diop, *La gloire des imposteurs* (Paris: Philippe Rey, 2014).

concerning an absence of sovereignty, viewed by an African youth whose aspirations are often out of step with those who represent them, and which this youth can no longer bring themselves to bear. This younger generation of Africans demands dignity from their representatives,[7] and for this dignity to be granted what is required first of all is autonomy in politics, economics, and security. It is probably in music that this aspiration best makes itself heard.

In the music of Tiken Jah Fakoly, through simple and efficacious lyrics, backed by the one-drop of cutting reggae-roots, we hear the expressive call for a free and proud African consciousness, taking its future in its own hands and going to work to rebuild the continent.

However, more recently one can notice a shift in the themes discussed in Tiken Jah Fakoly's artistic expression. The subject of his music becomes less focused on victimhood and more directed toward self-responsibility. This artistic evolution is rather interesting. Healing from an ailing consciousness happens through work on language. This means having to break free from handicapping, limiting, reductionist denominations such as "underdeveloped," "poor," and "clandestine" that reduce and restrict one's reality to a deficient dimension. It means above all to no longer pose as victims of History, but as subjects of one's own history.

Didier Awadi's hip-hop comes from a noncomplacent critique of the regimes and satraps in place, a call for a revolution of practices and mentalities on the continent, starting from a foundation of pan-Africanism. Daara J Family's music articulates a reflection concerning the resources of African culture and civilization for building the continent's future. As for Xuman, his music culminates with social chatter: decrypting daily life, finding some meaning from it all and inscribing it back into collective memory. In the

7. When African nationals are assassinated in Western countries or in the Maghreb as a result of racism, the reactions of our leaders are weak or inaudible. Sometimes even when members of their diplomatic body are mistreated, the same deafening silence remains.

artistic and musical work of Ghanaian Blitz the Ambassador we find an afropolitanism that mixes urbanity, globality, and African resources. Millions of young people listen to these artists, resonating with their beats and lyrics. Along with these artistic-political figures, Mandela, Lumumba, Sankara, and Nkrumah still remain the heroes of this African youth because they are bearers of a discourse of independence, autonomy, and self-respect that this youth are desperately searching for (in vain) within the contemporary figures from the African continent. Mandela's case is emblematic; beyond his place in the triumph over apartheid he knew how to put into action a political vision stemming from cultural and philosophical resources from his African tradition. The Ubuntu philosophy "I am because we are," being based on the social essence of the individual, privileges the common good and a respect for the humanity of the other. After his liberation, this led Mandela to refuse siding with any vengeance from the black community discriminated against during apartheid, even going so far as to challenge the imprescriptibility of the crimes against humanity committed during apartheid.

The recovery of self-confidence is also brought about through a retelling of one's history. UNESCO has undertaken an important and ambitious project concerning the general history of Africa with the aim of providing a much more definitive, overarching history of Africa since the dawning of the first appearance of humankind on Earth all the way to the present day, thereby granting a much needed and significant historical place to periods prior to the slave trade and colonization. It has already published eight volumes, of which the last covers the period from 1935 to the present day. The principal effect of this work will be one of a much vaster memory: repositioning Africans within a longer time frame in relation to their history in order to allow them to close the parenthesis on the continent's darkest hours, notably, to no longer make the slave trade and colonization the central pivots of their long

history, so as to reflect a much larger history that is both ancient and complex.

Sometimes, in music, the desire to rediscover the lost name of Africa can be read. This desire has had many names bestowed upon it: Gondwana, Akiboulane, Azania, Farafina. A longing to rediscover a lost identity can be felt, a desire to distance oneself from a name that has, at this moment in the cycle of history, taken on a pejorative connotation. However, the solution will not come from a nostalgia for the past but from a greater presence of one's best self. Individuals and societies are the result of what has persisted within them from their history and the syntheses they produce. The positive values of African cultures are present and persistent; it is simply necessary to explore and make use of the dynamics and the moral, physical, spiritual, and creative resources that they contain inside them.

5

The Revolution Will Be Intelligent

The cultural, economic, demographic, and political stakes African nations must confront have been called a revolution of practices and paradigms. The question of education and the formation of human capital is vital for taking charge of these paradigms and practices. The third revolution, after the industrial and agricultural revolutions, is the digital revolution—the information society—founded upon knowledge and innovation whose diffusion has been accelerated by information and communication technologies. The contribution of immaterial capital to the wealth of contemporary nations has become so important that, from now on, we speak of knowledge economies.

Throughout first decade of the twenty-first century there was a large improvement in the net rate of education at the primary school level throughout the African continent, most notably in sub-Saharan Africa. The percentage of people receiving primary school education went from an average of 58 percent in 1999 to 77 percent for most countries, with certain disparities still remaining, some countries achieving a 90 percent education rate and others 60 percent.[1] Primary schools, middle schools, and high schools are

1. According to a global report on education for all by UNESCO from 2013–14, the net rate of enrollment in preschools rose from 10 percent to 18 percent from 1999 to 2011, the net rate of enrollment in primary school education increased from 58 percent to 77 percent, the net rate of enrollment to get a university degree increased from 29 percent to 49 percent, and the rate of literacy in adults increased from 53 percent to 59 percent.

being built in villages and cities all over the African countryside, and education for all will be achieved within the next decade. In addition to these strides in early educational progress and access, there are also clearly other signs indicating ongoing advances in higher education and quality research at the university level. Nevertheless, the edification of societies truly founded on knowledge requires more important investments in education, professional training, and scientific research.

Despite this notable progress, the resources allocated to these educational areas remain largely below[2] what is truly necessary to start a chain reaction and establish virtuous circles of learning.[3] However, beyond the simple necessity for quality education for the masses, there is a fundamental question concerning the nature of the various forms of knowledge that need to be promoted and transmitted. The mastery of technical forms of knowledge with the goal of creating a more efficient society has become the object of a consensus, even if these technical forms of knowledge are not neutral and therefore imply that their impact on society must also be understood.

The social sciences as well as the human sciences focus on other questions. Their role is first and foremost to contribute to a more fine-tuned understanding of societal dynamics, without which no real perspective on the positive transformation of societies is possible. It so happens that within the human and social sciences, the corpus of knowledge about Africa is largely marked by colonial ethnology and anthropology. Valentin-Yves Mudimbé has proposed a name befitting of this corpus: the *colonial library*. Since the fifteenth century, the landscape of Africa has been structured by

2. Education spending went from 4 percent to 5 percent of GDP in African countries from 1999 to 2011.

3. These circles of learning are put into place when scientific production contributes to an increase in added value through innovation, and where this added value, in return, allows for a better investment in the production of the forms of knowledge necessary for taking responsibility for not only the present African societies but just as much its future societies.

discourses whose objective was to physically dominate the lands, to reeducate the mentalities of native inhabitants, and to integrate the local economic histories into a Western perspective.[4] These various forms of knowledge, principally motivated by the objective of governmentality and whose goal was the justification and establishment of the colonial enterprise, viewed non-Western countries through the prism of cultural superiority and racial prejudice. And unfortunately, they continue to largely structure the perception of the African real and have become an element of the perpetuation of domination if not one of inherent dependence. Rajeev Bhargava,[5] in taking a special interest in the case of India, has deciphered what he calls the epistemic injustice of British colonialism. He demonstrates how, with the goal of controlling the resources of colonized spaces,[6] the system of meaning and categories allowing for the individual and collective orientation of dominated peoples have been replaced by the meaning and categories of the colonist, and how this is done by way of an internalization of inferiority and a denigration of the values of the local communities, as well as their system of signification. This internalization of inferiority of the cultural and epistemic frameworks belonging to colonized

4. V. Y. Mudimbé, *The Invention of Africa: Gnosis, Philosophy, and the Order of Knowledge* (Bloomington: Indiana University Press, 1988).

5. Rajeev Bhargava, "Pour en finir avec l'injustice épistémique du colonialisme," *Socio* 1 (2013) : 41–75, https://socio.revues.org/203.

6. "And in fact, in order to maintain the economic asymmetry between the colonies and the Metropole implied that the latter exerted a quasi-absolute political control over the colonies. And yet, this control would have been impossible without largely shared belief in the cultural dominance of the colonizers. It was of vital importance, so as to establish this sense of superiority, to not simply conquer the lands and the resources of the colonies, but also their culture as well as their hearts and minds [*esprit*]. As a result, the economic and political injustice that is inherent in colonization adds one more layer of cultural injustice. One of its forms being epistemic injustice: this injustice starts taking cover when concepts and categories thanks to which a people understand itself as well as its universe are replaced or affected by the concepts and categories of the colonizers." Bhargava, "Pour en finir avec l'injustice."

peoples is a process that is first of all deployed within the discourse of the colonizers and then becomes crystallized within theoretical works whose primary focus was in the end the colonizers themselves. This was the same process at work in the Western colonization of Africa.

Mudimbé, Kwasi Wiredu, and Ngugi Wa Thiong'o are all interested in the question of the liberation of (philosophical, literary, and scientific) African discourse and the possibility for the field of African social sciences. For these thinkers, it is of the utmost importance to become the subject of one's own scientific discourse and to determine its practice according to one's own norms and criteria. In *L'autre face du royaume*,[7] Mudimbé lays out the strategy for creating this program: "For us Africans, our task will be to invest in the sciences, beginning with the social sciences and human sciences in order to grasp the tensions at play, to reexamine for our own sake the contingent findings and sites of enunciation, of knowing what new sense and what path to propose for ourselves and our search so that our discourses justify our singular existences engaged within a history that is itself just as singular. In short, we must rid ourselves of the stench of an abusive father: the stench of an Order, a region, . . . that is specific to a culture, but which paradoxically is seen as fundamental for all of humanity."

The question that emerges for these thinkers is the price of adapting to the thought of the other, the consequence of which could very well be the pure and simple disappearance of singular sociohistorical experiences. Exiting a dialectics of "appropriation and alienation," an appropriation whose corollary is expropriation (losing one's memory in order to assimilate that of the other),[8] can only be done by way of ridding oneself of the stench of the father.

7. Valentin-Yves Mudimbé, *L'autre face du royaume: Une introduction a la critique des langages en folie* (Lausanne: L'Âge d'Homme, 1973), 35.
8. Justin Kalulu Bisanswa, "V. Y. Mudimbé: Réflexion sur les sciences humaines et sociales en Afrique," *Cahiers d'Études Africaines* 160 (2000) : 705–22.

Ridding Oneself of the Lingering Stench of the Father

What is at stake here is performing a radical transformation in regard to the social and human sciences (humanities) as they are currently envisioned and taught inside African universities. Nevertheless, escaping the *re-production* of mimetic teaching[9] requires that some necessary preconditions must first be met. First and foremost, it requires a thorough comprehension of the current modalities of the integration of Africa within the myths of the West.[10] The Westernization of the African continent is no longer simply at the stage of a theoretical project: "it is an activity in movement" even if African cultures are putting up a fierce resistance to it. Moreover, the first construction site will consist in "clarifying the complex question of the connections binding Africa to the West, determining the exercise of thought, knowledge practices, the attitudes of beings, and ways of life."[11]

This reconstruction project requires reworking the social sciences, starting with the epistemological integration concerning the objects, methods, and status of knowledge produced by the social and human sciences as they are applied to African realities. Deconstructing colonial (ethnological) reason starts with a radical critique of the produced discourses, their theoretical frameworks, their ideological underpinnings, as well as the logic used to "pathologize Africans"[12] and dominate them. The knowledge of

9. Thomas Mpoyi-Buatu, *La re-production* (Paris: L'Harmattan, 1986).

10. Mudimbé, *L'odeur du père*.

11. "Escaping the hold of the West presupposes appreciating exactly what the price is for detaching oneself from it: this presupposed knowing to what extent the West, perhaps insidiously, bears a close resemblance to ourselves, it presupposes knowing what allows us think counter to Western forms of thought, and also what still remains Western in our recourse against this Western thought that which resides in our thought that is still perhaps a ruse that pits against us and through which it continues, immobile and elsewhere, expecting our arrival." Mudimbé, *L'odeur du père,* 12–13.

12. "The West created the savage in order to civilize it, created the concept

the other starting from the knowledge of the Other reduces the subject, who is (or becomes) the other of the Other.[13] In order to restore the fecundity of the African social and human sciences, we must call into question the universality of knowledge originating from Western societies. This act of speaking for oneself, of being simultaneously critical of Western knowledge regarding Africa but just as critical of the knowledge discourses that Africans hold onto in regard to their own history[14] and their own culture is of the utmost importance. Africans must be as critical of and attentive to their own modes of knowledge to the extent that these very forms of knowledge often find their justification within the same Western theoretical apparatus that enclosed Africa within a narrative of barbarism, primitivism, savagery, orality, and paganism.

For Wiredu and Mudimbé, in order to finally escape from a scientific alienation that is constantly lying in wait, African researchers must take on the responsibility of a thought that bears on their own destinies through establishing *a scientific discourse that would be the expression of material life within their own sociopolitical contexts.* This activity of thinking must root itself within the present, placing a careful attention on its own specific archaeological environment and the real tendencies of Africa's various societies and their most complete and concrete expressions. It is a question of integrating the true complexity of African social formations, of no longer considering them as mere carbon copies of Western history but as having their own cultural and historical specificity.

Mudimbé emphasizes that the simple analytical critique of the

of under-developed in order to develop, the concept of the primitive in order to form ethnology." Mudimbé, *L'odeur du père,* 57.

13. Bisanswa, "V. Y. Mudimbé."

14. "To proclaim a new speech that speaks our hopes as much as our illusions, today. But this is only truly possible as a choice if, previously, we have taken up, today, a new critical and radical reading of the past, of its traditions, its mythical trappings [*pompes mythiques*] and their networks of meaning." Valentin-Yves Mudimbé, *Les corps glorieux des mots et des êtres* (Montreal: Humanitas, 2005).

discourses made by non-Africans about Africa does not truly allow for Africans to take back up the activity of speech so as to affirm its singularities in a mode other than that of a kind of alibi. In order to think, one must start out from one's own situation and one's own structures. "The singularity of historical experiences is self-evident. One can attach one's own norms of intelligibility to every experience without a necessary intervention of instruments or privileged categories of another experience."[15] There are internal and dynamic logics specific to every historical field.

Mudimbé wonders if the desired African discourse could be achieved by replacing European languages with African languages. Changing the linguistic instrument of knowledge and scientific production could produce an epistemological rupture and open up a much-needed pathway toward a welcomed new adventure in Africa, in the same way that, by transplanting the methods, techniques, and uses of knowledge received from Egypt into their own language, the advocates of Greek thought triggered a reorganization of knowledge and life whose essential order is still in development. Concerning this point, Mudimbé is in complete agreement with Wiredu and Ngugi Wa Thiong'o, who estimate that returning to and rediscovering the vitality of African languages would not only allow for the decolonization of minds and imaginaries but also reveal the interiorities and signifying universes inscribed within an order of the world that intimately shapes meaning for Africans. Languages open up galaxies, universes, and worlds one must explore. African languages are privileged entry points into taking care of and managing the cultures in question as well as their contents in terms of thought and forms of knowledge. The work of Benveniste and Wittgenstein[16] has provided evidence for

15. Mudimbé, *L'odeur du père*, 185.
16. Émile Benveniste, "Catégories de la pensée et catégories de langue," *Problèmes de linguistique générale* (Paris: Gallimard, 1971), 63–64 ; Ludwig Wittgenstein: "les limites de mon langage signifient les limites de mon monde,"

the link between thought and the syntactical and grammatical structure of languages.

The difficulty of toppling the statue of the father, however, resides in the fact that we can only do so by way of convoking it, as Justin Kalulu Bisanswa notes.[17] The speech of African intellectuals trained within Western universities doesn't seem capable of detaching itself from the archaeological site where it was born. Often this speech is performed within the rifts of dominant scientific practice, unable to announce itself as a will toward a renewal. The possibility of thinking for oneself can only be fruitful if it can detach itself from the ideological systems that constituted its foundation and framework. It is a question of succeeding in thinking against one's intellectual genealogies and epistemic tradition.

The major obstacle to such an attempt is nevertheless the determination of an epistemological field, that is, the specific objects to understand as well as the singular methods for achieving this understanding. For quite some time, the question of epistemological decentering has been an object of debate for certain African philosophers. It can be heard ringing out in the work of Fabien Eboussi Boulaga in regard to the necessary mode of healing from the neurotic and pathological form taken on by encountering oneself [la rencontre avec soi] after the violence of colonialism. A recurring critique addressed to the Western conception of knowledge is that it overestimates the prerogatives of the subject by founding itself on the illusion that this subject, by way of its own means (reason and/or sense), can produce a thought that takes into account the complexity of the real. The trap of European methodology consists in selecting unique criteria for explaining this

Tractatus logico-philosophicus (Paris: Gallimard, 1961). Alexis Kagamé, a Rwandan philosopher, has shown how much of Aristotle's ontology is derived from Greek grammar.

17. Bisanswa, "V. Y. Mudimbé."

subject. Issiaka-Prosper Laléyê[18] questions the desire for producing, as a material of knowledge, a reality exclusively subordinate to the analysis of experience and the debate around reason. He critiques the fruitfulness of a methodological approach based on the principle of the excluded middle.[19] To understand the real, this approach distinguishes the subject from the object. The punctualization of the object and the splitting of reality into tiny parts that we then try to stitch back together is the result of a residual positivism within the Western gnoseological tradition. This tradition is an inheritor of atomism, which began over two thousand years ago. This approach was useful for the development of physics and the exact sciences, but Laléyê is quick to demonstrate how this method reveals itself to be unproductive in the areas of human sciences and social sciences, since the objects of study have depth and the subject is not detached from the object. As for quantum physics, the position of the observer modifies the thing observed.

A generation of young African thinkers has taken back up this debate and inscribed it within a mode of a dialogue of epistemes and shared experiences. For Nadia Yala Kisukidi, it is about "creating new critical epistemologies that are neither overly disciplinized nor didactic . . . and which take into account the situation of utterances of the subjects who were once colonized, dominated not only within the order of pre-constituted forms of knowledge but also within their own open and active traditions."[20] Thus Kisukidi proposes constructing the conditions of a new epistemology in rethinking "historical experiences founded on domination in

18. Issiaka-Prosper Laléyê, paper given during the conference "Le clos et l'ouvert: Acteurs religieux et usages de la rue," organized at Gaston Berger University (October 29, 2014).

19. This concept is also challenged in the heart of the Western episteme by the adherents of quantum physics and by thinkers such as Nicholas Georgescu-Roegen, a proponent of transdisciplinarity and the principle of the included middle.

20. Nadia Yala Kisukidi, "Décoloniser la philosophie: Ou de la philosophie comme objet anthropologique," *Présence Africaine* 192 (February 2015): 83–98.

order to reform them within a shared history; a hope for reciprocal recognition, giving back to everyone their history, culture, and dignity."[21]

Nevertheless, the preliminaries for dialogue and the constitution of shared experience require the recalibration of force relations, and all the more so considering a project for reestablishing the paradigms of domination also exists. Blondin Cissé notes that the attempt, in France, to have a vote regarding Article IV[22] of the law of February 23, 2005,[23] evoking the positive role played by colonization, or, for example, the use of terms such as "third world,""underdeveloped countries," and "developing countries," are a result of this project of perpetuating epistemes of domination and the hegemony of Western culture.

21. Marie-Claude Smouts, *La situation postcoloniale* (Paris: Presses de Sciences Po, 2007), 33.
22. "In particular, the academic programs recognize the positive role of the French presence abroad, most notably in North Africa, and grant to the history and the sacrifices of troops of the French army stationed in these territories an eminent place which they have right to."
23. French Law Number 2005-158 from February 23, 2005, "The French Law on Colonialism," recognizing the national contribution in favor of repatriated French citizens.

Inhabiting One's Dwelling

African cultures and cosmologies can provide a wealth of inexhaustible resources for the project of epistemic decentering. Having exhausted technoscientific reason and confronted the civilizational consequences of its impasses, new metaphors are required for the future. We must heed the call for a renewal of the very sources of the imaginary and of a thought coming from an elsewhere. For Africans, this will be achieved through a better integration of their own universe of references in the quest for an equilibrium within their own societies.

In order to avoid the traps of the colonial library, Africans must return to their own cultural resources through reacquainting themselves with these sources of knowledge, founded upon each specific culture's own gnoseological criteria, that is, from the reference points coming from these cultures themselves. This is what Wole Soyinka has called *self-apprehension*. For Soyinka, an apprehension of self through one's self, without a reference to the other,[1] determines the possibility of a thought (and of a literature) that is truly African.

To those who quickly brandish the specter of essentialism, Soyinka reminds us that Africans didn't simply wait for the Europeans in order to "get to know themselves."[2] Every culture contains an

1. Étienne Galle, "La vision du monde yoruba dans la pensée critique de Wole Soyinka," *L'Afrique Littéraire* 86 (1990): 84, cited in Bernard Mouralis, *L'Europe, l'Afrique et la folie* (Paris: Présence Africaine, 1993).

2. Mouralis emphasizes that this form of apprehension of African culture

intimate form of knowledge that cannot be acquired from out-
side of it.

The philosophers who have opened the debate concerning the
necessity of African social sciences have barely questioned the idea
of simply apprehending the African real exclusively through sci-
ence. Their project has principally consisted of an attempt to de-
Westernize scientific knowledge and gain a better understanding
of Africa through a revision of epistemological postures. The legit-
imacy of this method, which consists of attempting to grasp the
African real or reality [*le réel Africain*] through the tool we call sci-
ence, has not been called into question. And yet, a certain number
of reasons justify skepticism in regard to this scientific approach as
the only manner by which one can elucidate the real. Other modes
of apprehension for grasping the real also exist; Western forms of
knowledge do not exhaust all methods of scientific inquiry, and
moreover, for the phenomenology of perception, the world exists
only as an object of representation and as a discourse of a subject,
located within a given moment of an individual and collective his-
tory, dependent on one way of seeing the world; as a consequence,
we must begin an inquiry into what the real is.

Obviously, what must be undertaken is partly the work of dis-
placing the constituted fields of knowledge from within and begin-
ning again from this displacement. But we must also explore the
other possibilities offered up by various other forms of apprehend-
ing the real. These other forms of apprehension constitute modes
of knowledge that have demonstrated their functional utility over
long periods of time within diverse areas of human activity: ther-
apeutic and environmental forms of knowledge, technical know-
how, as well as social, historical, psychological, economic, and
agricultural forms of knowledge. All these various forms of knowl-
edge have ensured the survival, growth, and durability of African

in contrast to the ideology of authenticity is a social vision. It requires an ed-
ucation that is received from within the heart of all of the various societies
within Africa.

societies. In order to mobilize them, it is necessary to explore Afri-
can cosmogonies, myths, and diverse cultural expressions, as well
the linguistic sources of African languages. We must examine Afri-
can cultures through their own categories.

In this light, the work of the philosopher Mamoussé Diagne is
of fundamental import. The point of departure for his research
is an analysis of oral reason, in which he carefully demonstrates
its processes and modes of production as well as its methods for
the conservation and transmission of various forms of knowledge
[*connaissances et savoirs*]. By inquiring into the various types of
discourses within the oral tradition (proverbs, tales, epic narra-
tives), Mamoussé Diagne was able to identify not only the content
of African thought but also the way in which oral reason could
preserve and transmit this thought without having writing as a
medium of conservation or as a method for circulating these forms
of knowledge. In his *Critique de la raison orale*,[3] he demonstrates
the discursive processes at work within the heart of oral tradi-
tions and the practice of orality.[4] As a threat to all oral civiliza-
tions due to the absence of any material support for archiving,
time reveals the laws and intellectual processes that organize liv-
ing speech [*parole vive*] and its written inscription [*écriture*]—its
stabilization and transmission—into orality, processes irreducible
to those found within civilizations based around writing. Beyond
his work concerning the mechanisms that govern the production,
archiving, and transmission of individual and collective knowl-
edge, Mamoussé Diagne engages in a philosophical reflection on
the various forms of African thought and their content, leading

3. Mamoussé Diagne, *Critique de la raison orale: Les pratiques discursives en
Afrique noire* (Paris: Karthala, 2005).
4. *Dramatization* is the means by which traditional African speech ensures
its durability through history. A vehicular form of knowledge within civiliza-
tions of orality, it is a technique that directs the modes of elaboration of trans-
mission and archiving of cultural heritage of oral civilizations. The *memorable
event* [*le memorable*] is a discursive strategy aiding in the prevention of the
culture of a group from falling into oblivion, from being forgotten.

him beyond literal interpretation [*litteralité*] into exploring the *non-dit*, the unsaid.

Through their research, Mamoussé Diagne and Bonaventure Mve Ondo take part in the ongoing debate concerning a theory of knowledge staked at the limits of the Western vision of what a form of knowledge is. They emphasize the diversity of approaches to the real according to different civilizations and eras, the plurality of modes of knowledge, and the gnoseological and epistemological relativity. The borrowed path of Western reason is merely one among many. Mve Ondo calls for a refusal of the exclusivity of a logocentric episteme and of the controlled verification of reason by way of the specific mode of written thought.[5] According to Mve Ondo, we must also carefully consider another form of episteme connected to ontomythology, namely, an ontology whose source is steeped in myths and traditional narratives, which is not exclusive to African thought but which originates in every society where the vehicle of the communication of thought is essentially spoken language [*la parole vivante*] and not written speech.

In *Penser l'humain*, Abdoulaye Elimane Kane examines the way in which this "African perspective" expresses itself within human thought, without falling into some kind of culturalism or essentialism. He points out that "the diverse expressions of the human are the signifiers of the same signified: humankind [*l'homme*]."[6] The conception of the universe that manifests itself within the diverse forms of African knowledge and practices is that of a cosmos considered as a great living being [*grand vivant*]. This living being is a whole of which humankind is only one expression, one living being among others, and at the same time, an archetype that acts as a measuring stick for all things: the cosmos, space-time, social organization, the profane, the sacred.

Humankind is considered as a symbolic operator connecting

5. Bonaventure Mve Ondo, preface to Diagne, *Critique de la raison orale.*

6. Abdoulaye Elimane Kane, *Penser l'humain: La part africaine* (Paris: L'Harmattan, 2015).

the heavens to the earth. From this perspective, the world is subjected to the principle of entropy; it deteriorates, and whether or not humankind is the sole entity responsible for this, the ritual restoration of the world constitutes one of the most meaningful symbolic acts of humankind's realization of this responsibility. The essence of political power therefore consists in reestablishing and repairing this order. The function of humankind's political power and vision of responsibility stems from this conception of the universe.

Within the Yoruba culture, the world is first and foremost understood as a field of dynamic flows of experiences, a space of visible and invisible, destructive and creative encounters. Its divinities and ancestors are governed by the same laws as humans and are placed into the fourth dimension: the transitional space between the past, present, and future.[7] Immersion into the cosmos allows one to overcome the anxiety and anguish that these shifting flows of forces generate, and helps one to better understand the cosmos.

The world is an enigma one must decipher; the idea that we can decipher all of its laws and base our actions upon them is an illusion. Knowledge concerning the cosmos is acquired by way of properties of both the mind or spirit [l'esprit] as well as the real; a confrontation with the real helps to avoid an excess of both subjectivity and objectivity.

African cosmologies[8] relativize the omnipotence of the subject. For them, the subject is a transitory aggregate of psychological and biological elements susceptible to metamorphosis and passage into different orders of reality. These cosmologies are skeptical as to the capacity of discourse to completely take into account all of reality and to reflect the order of things. The ultimate nature of reality transcends our faculties of reflection and expression. A vitalist ontology is shared by several systems of societal modes of thinking

7. Mouralis, L'Europe, l'Afrique et la folie.
8. As is the case in the East (e.g., in Japan and China).

within varying African cultural milieus; for the Bantu people, the Dogon, and the Serer, the cult of the life force is the founding principle of their religions.[9] Souleymane Bachir Diagne notes that an ethics of action flows from this ontology of a vital force, an ethics that could be described in the following way: "Always act in a way so as to intensify the life force of all the *muntu*."[10] As such, evil is the decrease of the life force and good is its increase.[11]

Cosmogonies and ontomythologies reveal a worldview and, starting from there, African societies' relation to the real or reality [*le réel*] as well as the role and function assigned to humankind within the cosmos. The end goals of social life, the relationship with the environment, the function of politics and of the sacred, are thus structured by systems of thought that flow from these cosmogonies and ontomythologies. African religions combine an ontology of immanence with a vitalism and maintain a conception of the universal characterized by its absence of hegemonic intention.[12]

Over a period of fifty years, social, political, and educational systems can change: this is precisely the case with colonial Africa.[13] But the various worldviews, systems of thought, and epistemic frameworks arising out of African cultures—along with the profound life philosophy that they transmit—have never stopped being a driving force within African societies.

These primary or initial motors, whose productive force is

9. The work of René Lumeau and Louis-Vincent Thomas, which focuses on several oral narratives arising from a number of African religions, seems to attest to this idea of a convergence of vision at the heart of African religions.

10. *Muntu* means "human or humankind" (intelligent being), and its plural form is *bantu*.

11. Souleymane Bachir Diagne, *L'encre des savants: Réflexions sur la philosophie en Afrique* (Paris: Présence Africaine–Codesria, 2013), 32–33.

12. Kane, *Penser l'humain*.

13. Lilyan Kesteloot, preface to *La royauté de la mer à Fadiouth: Aspects de la religion traditionnelle seereer (Sénégal),* by Virginia Tiziana Bruzonne (Paris: L'Harmattan, "Oralités," 2011).

profound and sustainable (despite the grafts they have undergone), are precisely the driving spiritual life affirming forces that one must decipher and fortify within an open activity of re-cognition [*re-connaissance*] of self. The cultural and epistemic frameworks[14] of societies are the result of historical and dynamic processes. These systems of meaning can therefore evolve as a result of both internal and external conflicts. And this can be seen either in the way the group, having tested its values, sees the need to renegotiate them, or how a group's values evolve due to an external conflict. In extreme cases this process can even lead to profound changes in the group's values, and sometimes even to their disappearance. What is important here is to grasp the present forms and current mutations of these values already under way.

In order to do this, there must be a revolution in the recognition of the various African modes of knowledge formation [*modes de connaissances*], signaling an end to the traditional Western intellectual hegemony through the elucidation of non-Western forms of knowledge that continue to flourish and be preserved within African societies. This revolution is not only necessary; it is urgent. Martial Ze Belinga[15] recommends a return to these epistemogonies through an exploration of the precolonial library, particularly since this library has provided Africans with a cultural and cognitive capital that, despite the weak level of education rates for some, has allowed them a way to achieve exemplary performances within educative systems structured by other rules and for other types of competence (Nana Benz,[16] world-class artists, and informal

14. An epistemic framework is a system of meaning and signification, historically generated and collectively maintained by the transmission of cognitive resources to future generations, thanks to which a group understands and evaluate the individual lives of its members and the collective life of the group.

15. Martial Ze Belinga, "Économies de la culture, discontinuités discursives, créativité épistémologique," *Présence Africaine* 192 (February 2015) : 55–82.

16. [The women merchants who became known as Nana Benz have become a legendary example of alternative and creative entrepreneurship for their textile business in Togo, which began in the 1930s, even before Togo's in-

entrepreneurs). This rediscovery of African modes of knowledge must be accompanied by a critical theorization of African cosmologies and complemented by the freedom to choose, within other kinds of epistemes, through creative assimilation,[17] the elements of a fruitful hybridization.

Escaping Subalternity[18]

We cannot conclude our current reflection without some thoughts concerning its practical translation into present-day African universities. These universities (in Dakar, Makerere, Nairobi) are a manifestation of colonial administration. They are not the result of the free will of independent African nations, equipped with the instruments helping them to resolve their social problems. Since their creation, these universities have experienced little in the way of profound structural transformations, and this has been the case despite a growing number of African teacher-researchers practicing their vocation. Furthermore, these universities have not properly adapted to their sociocultural environments. The curriculum used by the faculty has largely gone unchanged, without any sort of updating, and has simply been copied off the Western mother-universities. Ambroise Kom emphasizes that such a university is a privileged instrument for the perpetuation of hegemonies, since it is the site where one educates the agents of reproduction and perpetuation of a vision of Africa that was constructed elsewhere,

dependence. They have become a shining example of ingenuity all around the African continent.—Trans.]

17. The notion of creative assimilation implies an "intelligent ownership of what we want to hold onto and an intelligent rejection of what we don't hold onto, that is to say, through clarifying the reasons of this rejection" (Sri Aurobindo.)

18. This section owes a significant amount of gratitude to the chapter "Université, quel destin?" from *L'odeur du père,* by Mudimbé, as well as the public lecture by Ambroise Kom, "S'approprier l'Université: Escaping from Subalternity" (December 12, 2003), at the University of Buca in Cameroon, published in Ambroise Kom, *Le devoir d'indignation: Éthique et esthétique de la dissidence* (Paris: Présence Africaine, 2012).

striving to solidify itself in order to perpetuate domination. Given that power is fundamentally linked with representation,[19] these universities were conceived of as the crowning achievement of the project of colonial civilization.[20]

By establishing the university system in Africa, it becomes clear that the colonial authority standardized the representation that it wanted to present of itself as well as the representation that Africans had of themselves: an image inscribed in subalternity. The colonial university thus allowed for the inscription of the other into its narration within a position of inferiority, convincing the other of the necessity of his dependence on the connections the colonial university established with the African citizen, and all the while sending a mythified feedback image of itself and devaluing that of the African citizen through a truncated reading of Africa's various histories and cultures. International university cooperation functions according to a similar schema. Since the large majority of funding for scientific research in Africa comes from external sources, the scientific agenda is consequently also standardized from outside of Africa. African researchers thus find themselves in a position of *informers* or subcontractors of questions and issues that are in no way result of their own epistemological priorities. If this is the case, then how do we provide a younger generation of Africans with a positive representation of themselves, based on theories elaborated outside of Africa whose goals are to keep them within a position of subalternity? How can we help provide them with the space to reinvent themselves without becoming alienated?

Each country must be capable of adapting its university research and teaching methods to its political, economic, and cultural needs.

19. "Power is related to representation: which representations have cognitive authority or can secure hegemony, which do not have authority or are not hegemonic." John Beverley, *Subalternity and Representation: Arguments in Cultural Theory* (Durham, N.C.: Duke University Press, 1999), 1.

20. Félix-Marie Affa'a and Thérèse Des Lierres, *L'Afrique noire face à sa laborieuse appropriation de l'Université: Les cas du Sénégal et du Cameroun* (Paris: L'Harmattan/Les Presses de l'Université de Laval, 2002).

In order for there to be a fruitful enculturation and appropriation of the university, it is not simply a question of reforming the university system inherited during colonization, but rather of totally deconstructing it in order to build the foundations of a new African university responding to the demands of its societies.[21] This deconstruction must traverse a demythification of Europe with a strategy of reconquering Africa's own being in the world.

In order to accelerate the end of one world, to undo Africa's dependence on the West for its own cultural representation, it is necessary to win the battle of representation through a strategy of subversion and insurrection,[22] leading to the completion and elaboration of Africa's own discourse about itself. This process takes place by way of the action of once again equipping oneself with the capacity for choosing what one retains of the other in regard to pedagogy and knowledge production in relation to one's own cultural representation.[23] For the conditions of truly making one's own decision to be valid and present, it follows that existing alternative solutions must also be available, allowing for this choice to be freely consented to and thus truly made. For this to be possible, it is of the utmost urgency to massively invest in the reappropriation of the various forms of knowledge within continental Africa—oral reason and the precolonial library—alongside the forms of knowledge coming from the rest of the world.

21. There already are attempts of enculturation taking place inside the younger African universities. In 2011, Gaston Berger University created a department of Civilization, Religions, Arts, and Communication (CRAC), which has as one of its objectives the exploration of the various forms of knowledge arising out of African societies and then teaching these forms of knowledge within the university.

22. Homi Bhabha, "The Postcolonial and the Postmodern: The Question of Agency," in *The Location of Culture* (London: Routledge, 1994), 245–82.

23. Ambroise Kom emphasizes that the university models, invented by Europeans during the Middle Ages, have seen a large evolution in their functioning since American universities began adopting them. And while American universities have indeed inspired Asian universities, Asian countries have also constructed their own university models adapted to their specific needs.

The university will only be fully African when it becomes capable of contributing as fully as possible to resolving the contradictions within African society and of taking up its own part in the creation of new social forms.[24] It is in this way that the African university will finally respond to the transformations under way within its various societies. It will therefore also be a question of rethinking the dissemination of knowledge within the social body of African societies, perhaps through a *dis-academization* of this knowledge.

24. Mudimbé, "Université, quel destin?" in *L'odeur du père*, 101.

7

Charting One's Own Course

On the first night of the 2015 festival launching the new fall publishing season in Mali, Ibrahima Aya[1] invited me to speak on the theme "Dare to reinvent the future." There was something immediately a bit disturbing about this kind of formulation. This affirmation of will presumed a certain dose of audacity and energy before "throwing" oneself into reinvention. Behind the bravado of the declaration, a certain hesitation could be glimpsed faced with the scope of such a task, which justified the use of the term "dare." Reinventing the future is not something self-evident. In order to take up such a task, one must have a bit of temerity. It was a question of inventing things anew, since the future already seemed to be given. All its routes and places, the paths that lead there, the prairies for grazing, were already clearly marked. The ideal image of the future was already visible in Western Europe and North America. And for those who could gain access to these protected territories, television already provided a faithful *reflection*.

After the conference presentations and the subsequent debates of the festival, Sami Tchak[2] summarized the situation with a rather terse declaration: "When are we going to stop using other people's

1. Director of editions Tombouctou and organizer of the annual literary festival of Mali.
2. Sami Tchak is a Togolese writer living in France. He is the author of *Place des fêtes* (Paris: Gallimard, 2001), *Hermina* (Paris: Gallimard, 2003), *La fête de masques* (Paris: Gallimard, 2004), *Filles de Mexico* (Paris: Mercure de France, 2008), and *La couleur de l'écrivain* (Ciboure, France: La Cheminante, 2014).

past to create our own future?" It was true. Most of the proposals for the reinvention of the future were taken from Western modernity's conception of imaginaries of progress: comfort, technological mastery, mass consumption, "development" in the form of economic adjustment—basically, a pale and sometimes poor imitation of a form of social organization administered to us by history. No future could be envisioned outside of this well-known form, which still seemed to capture everyone's imagination and continued to keep them enthralled. Some of these aspirations were legitimate: well-being, comfort, and so forth. Others were the fruit of the powerful fabrication of uniform desires across the modern world (or of the process we call globalization).

Pankaj Mishra[3] has examined the roots of this desire for emulating the West by societies from the global south, which consists of a systematic attempt to espouse North Atlantic societal, economic, cultural, and political forms while sacrificing the cultural wealth and singularities of their own societies.

At the level of the economy, since the early 2000s numerous economic visions of the future have emerged on the African continent. Alioune Sall has counted around a hundred. At the present time, within the fifty-four African nation-states, only seven do not have some sort of long-term economic vision for the future.[4] Africa seems to have recently converted to strategic economic planning. The multitude of plans for economic emergence that have been created in the past several years throughout most of the African nation-states bear witness to this fact. Agenda 2063 of the African Union is a recent illustration. This tendency seems to reflect a desire to take back control of one's own economic fate,

3. *The Romantics* (New York: Picador, 1999); *Temptations of the West: How to Be Modern in India, Pakistan, Tibet, and Beyond* (New York: Picador, 2006); *From the Ruins of Empire: The Intellectuals Who Remade Asia* (New York: Farrar, Strauss and Giroux, 2012).

4. Alioune Sall Paloma, director of the African Futures Institute (Pretoria, South Africa), noted this during a presentation to the general assembly of CODESRIA on June 9, 2015, at Dakar, "L'Afrique en quête de sens."

which has not always been the case. In 2000, high-ranking inter-
national financial institutions, such as the World Bank, created
certain fixed goals for development in the new millennium, the
Millennium Development Goals (MDGs): cut poverty rates in half,
improve literacy rates, and so forth. For those countries said to
be *in development*, these goals would become the framework for
their economic and social projects. However generous the propo-
sitions were (who can argue with the reduction of poverty?), once
again they ended up being nothing more than teleological appro-
priations of these countries' futures. From that point on, all the
countries that found themselves considered as *developing coun-
tries* were united around common goals, which sealed their fate as
sharing a common condition, which was, of course, that of being
poor countries, lagging behind in the development necessary for all
modern nations. These nations were called on to make progressive
changes over a fifteen-year period that would then be evaluated at
a specific fateful date. The masters would then verify and see if the
lessons had been duly learned and applied. Not that one shouldn't
also take into consideration questions of national health, nutrition,
education, and so forth. These concerns as well would be things
that so-called *developing* nations would take care of and apply by
way of their own programs, their own priorities and horizons for
achieving their objectives. A poverty that had been tolerated for
centuries had now become suddenly intolerable and had to be cut
in half within fifteen years.

The advantage of these strategic plans is the proposition of an
economic vision of the future along with a well-planned approach
for short-term, mid-term, and long-term goals, helping to put an
end to a kind of reckless navigation with countries flying by the
seat of their pants, or countries who had been pushed in direc-
tions by a diverse number of often contradictory winds. Never-
theless, the critique that one could address to them is that these
countries lack a sense of audacity and originality. For the most
part, the various economic visions taken up by these countries are

largely of the neoclassical variety and attempt, without any sort of discernment on their part, to apply these neoclassical economic visions to the trajectories of African countries. What's more, most of these strategic plans recommend a more improved insertion of the country's economy into the market of globalization, as if the latter were a neutral market or had the country's best interest in mind, whereas at the present moment the markets of globalization have only engaged with these countries to their economic detriment and have simply adhered to the globalized economic system that is already in place. To truly take advantage of the market of globalization, there must be a radical disruption of the guiding principles of this very market or some sort of renegotiation with Africa's relations with it by reconfiguring modalities of insertion within the process of globalization that are specifically advantageous for the local African economies.

From a symbolic point of view, the problem is derived from an uncritical return to the use of the concept of emergence, corresponding to the economic upturn in the five stages of economic growth according to Rostow.[5] This terminology confirms the idea according to which the African continent is *submerged*, that its head is underwater and that what first must happen is to rescue it from the onslaught of crashing waves and rising waters. We haven't even arrived at the point yet of talking about teaching the countries how to swim, which is more than likely slated as another step in the evolution of the countries' economic development to be taken down the road.

Here again we bear witness to a phenomenological reduction of African societal realities to the deficiencies of their economic

5. Rostow's five stages include: traditional society, the necessary conditions for growth, *take-off*, the phase of maturity, and the era of mass consumption. This linear and evolutionist vision of the progressive development of societies has been largely criticized. It has now simply become a historical reference of economic thought. W. W. Rostow, *The Stages of Economic Growth: A Non-Communist Manifesto* (Cambridge: Cambridge University Press, 1960).

dimensions alone. Nations that have been emerging if not thriving for thousands of years from a civilizational, spiritual, and cultural standpoint have found themselves consenting to the idea according to which they are submerged underwater. Perhaps in reality they actually inhabit the plains and plateaus, and there is no sea whatsoever sketched out on their horizon. If these nations emerged to the surface, what would they do to their own surface upon arrival? As such, without some sort of work of reconceptualization, this attempt of setting sail economically speaking will do nothing more than lead the boat back to its port of call, unable as it is to break free from the ideological moorings holding it back.

The expression of its own metaphors of the future must come about from establishing concepts arising out of the diversity of African cultures, concepts that express well-being, ways of living together in harmony, and which above all reflect the ways in which social groups envision what they consider as the good life for both the individual and the collective. A good example of this can be found in the philosophy of Ubuntu and its social ethics. Other examples include the concepts of *noflay* and *tawfekh,* found within Senegambian and West African culture, both evoking the idea of well-being accompanied by feelings of inner peace and serenity.

This endogenous production of concepts for establishing social innovations has already been experimented with in Rwanda.. For example, performance contracts—connecting district mayors to their various populations—are translated through the concept of *imihigo,* which in Kinyarwanda (or Rwandan) means "engagement with the community." Rwandan warriors heading out to battle performed *imihigo* with the community and tasked themselves with acts of bravery and heroism, and upon returning to their homes they brought back proof of these heroic and brave acts. These concepts, derived from a profound place within Rwandan culture or translated within local languages, have as one of their advantages being better understood by the local populations, but above all they provide something meaningful to them since they already

contain a deep resonance with their systems of signification. Because of this, these concepts are successful in engaging the populations within processes of social transformation wherein they can consider themselves as active participants, as co-producers of the meanings and significations associated with these transformations.

The Seduction of Completed Forms

Two contradictory tendencies can be detected within the contemporary African discourse. On the one hand is the desire for the production of an aim or goal that is marked by a sign of singularity; on the other hand is the desire for being within the time of the global, of globalization, and wedding itself to globalization's metrics and forms, a tendency that is derived from what we will call the seduction of completed forms. This tendency can be best understood when it is a question of inspiring the best possible inventive practices, of not reinventing the wheel when it has already demonstrated its utility. This tendency is also derived from a will to be the co-inheritor of an intellectual heritage and common culture of humanity, in order to have been a part of its conception as its co-producer. This seduction of completed forms is also a desire for participation in the common adventure, in a global élan, under the same modalities as the triumphant majority: the wish to play a musical chord that would vibrate in harmony and in tune with others, the desire to be in the family photo, and to dress like everyone else. The African pop music, the bands that have had "big hits" on the American billboard charts by simply providing a small dose of "African rhythm and melody" in their music that has obviously standardized itself and conformed itself for an international listening audience, can be viewed as being a result of this tendency (e.g., P-Square). At the opposite end of the spectrum, the music of Wasis Diop, born in a West African cosmos, strives to create dialogues between universes and worlds. His music straps its poetry onto the Wolof language and the imaginaries of the Sahel. The

evocative power and sensorial infusion of its melodies create signs whereby Africa, through expressing its beauty and mystery, evokes the universe.

At the same time, the desire of singularity inside the signs and forms can be seen as a way of how not to show up to a meeting empty-handed in regards to giving and receiving that was so dear to Senghor. To show up with one's own victuals to offer up to the other guests at the common table of the banquet. To always carry along, in one's messenger bag, the harvest of one's labor, the fruits derived from the seeds once planted in the soil, beaten down by the rains of the local climate, which grant to these fruits their unique flavor. The demand for that which is uniquely African comes from a desire for the recognition for what the African face has provided to the visage of human experience. It's a desire to construct a universalism that would this time be enriched by all the diverse singularities, of inhabiting a world that one considers as one's own, since one recognizes one's own signs within it.

The completed forms that we continue to see being re-created and reapplied within politics, within the construction of cities, within social, juridical, and economic practices, would attest to the idea that things have already taken on their definitive and final forms. That the world has been completed. That what is required is to "get in step with the rhythm of the world."[6] This kind of mimicry is anesthetizing and deadly. It marks the end of *poïesis* (creativity). It's a veritable amputation of the generic function of the human as creator.

Development, the nation-state, the institutional figures of representative democracy, the rapid pace of cities—these are all propositions made for wedding forms of social organization, of the regulation of the political and the economic resulting from selections undertaken by certain societies throughout the course of

6. Aimé Césaire, *Cahiers d'un retour au pays natal* (Paris: Présence Africaine, 1956).

their history, after a long process of trial and error. The advantage of those who come after this is that of not being obligated to reiterate the process in order to select the proper option. This is also valid within the technoscientific space where findings are much more easily replicated. As far as societal dynamics are concerned, the error would consist of taking ends (the completed forms) as the means. Societies are reticent upon arriving at the ports where they discover straitjackets tailored for bodies other than their own. This refusal explains that, despite the insistence, the grafts didn't take to the bodies. As long as political, social, and cultural institutions are not the result of internal productions that have arrived at a position of maturity where societies set into action the necessary syntheses for their own specific metabolisms, we still bear witness, for a long time to come, to a self-organizing real life outside.

Institutional innovation is required in order to create the forms of its own contemporaneity. In this light, Bado Ndoye[7] shows to what extent the servile imitation of political models elaborated according to the imperatives that in no way take into account the reality of local cultures can only lead to producing extroversion, namely, alienation. Conversely, a political modernity that is well understood is always underpinned by an endogenous dynamic that will know how to harmonize itself with the universal demands of human freedom and dignity.

7. Bado Ndoye, "Cultures africaines et modernité politique: entre politique de reconnaissance et exigence d'universalité", revue *Présence africaine* 192, (2015): 99–114.

8

Afrotopos

The future is a site that does not yet exist, but which one can already shape within a mental space. For societies, this nonexistent site must be the object of a prospective thought. As such, one works within present time in order to help to create its *occurrence*. Afrotopos is Africa's *atopos*: the as-yet-inhabited site of this Africa to come. It requires an investment in thought and imagination. Out of all the various sequences that structure the temporalities of human societies, the future is the one temporality upon which we can actually set ourselves to work and fully apply ourselves, by way of conceiving it and giving shape to it. Societies won't be subjected to any sort of grand historical collapse as long as they take up the task of conceiving of their future. They must have a concise vision of the future and take action within the present in order to transform their reality.

Thought, literature, music, painting, the visual arts, cinema, television series, fashion, pop music, architecture, and the lively energy [*élan*] of cityscapes are the spaces where the future forms of individual and social life are sketched out and configured. The world of tomorrow is in gestation within the world of today, and its signs are decipherable within the present.

The novel is one of the sites where contemporary African existential angst is best expressed. Here we glimpse not only the collective and singular experiences of individual fates but also very specific dreams and projections. Chinua Achebe's novelistic work was a singular artistic expression and description of the end of a world constituted by the experience of colonialism. The disillusionments experienced after the independence of African nations

were acutely expressed in the work of Ahmadou Kourouma and Alioum Fantouré. And the writings of Cheik Hamidou Kane and Valentin-Yves Mudimbé provide a superb glimpse into the psychological toll of the postcolonial period and the effects of the dissolution and ambiguity of various consciousnesses tossed about among various cultures. We also catch glimpses of the shadows and mysteries of the genocide of the Tutsi in Rwanda as well as the complexity and poetry of the real magisterially captured through the language of Wolof by Boubacar Boris Diop.

The work of Ken Bugul shines a light on the existential challenges of women striving to emancipate themselves from a patriarchal order and the seductions of the West. Emmanuel Dongala's work reverberates with an intensity of the fire of origins. With the work of Ayi Kwei Armah we see a reconstruction of a spiritual African consciousness drawing its strength from its most ancient (in particular, Egyptian) sources.

It would seem that a younger generation of African writers has delved into the most intimate, most personal, and most existential of questions: the search for oneself, hybridity, individuation, and inner freedom. One would have liked to pit this new generation of writers against these aforementioned elders as the *vox populi* and the soul of their communities. It just so happens that independently of the themes chosen by each of these writers, whether it be political, social, or more personally intimate, every one of their works has expressed the individual and collective lived experience of Africans as a whole. In each case, it's a matter of setting and perspective. The most personal of questions have had some sort of social context as their backdrop, and, inversely, societal problems have borne witness to each of these individual inner tensions. In *Half of a Yellow Sun*,[1] Chimamanda Ngozi Adichie perfectly achieves this *mise en abyme* of individual fates on the

1. Chimamanda Ngozi Adichie, *Half of a Yellow Sun* (New York: Anchor, 2007).

basis of social and political history. We also see her explore the way in which one can inhabit a variety of worlds, and how to navigate between their shores (in this case, Nigeria and the United States). Kossi Efoui unveils the shadows of the days to come and situates imaginary spaces through an energetic and profoundly poetic language. Nafissatou Dia Diouf deciphers the tensions of the various individual existences at the heart of African cityscapes and examines the synthesis of African and Western cognitive resources. With Célestin Monga's work we discover a thorough reflection concerning alterity, the dexterity of identities, and the conditions for an ethics of difference.

African writers living within the diaspora have also provided a fresh view of the continent through a view from the elsewhere of their exiles. Their anchoring point led them not only to think a cultural synthesis, nomadic identities and circular identities, but also to dream and fantasize about Africa. They are the outgrowths of the continent, cuttings planted in faraway lands and nourished from other saps. Abdourahman Waberi imagines an Africa that has become powerful and prosperous, and where one will find Europeans—and Asians as well as Americans—who are all living miserable lives in their own countries, deciding to relocate to Africa. Léonora Miano thinks Africa and the project for reconstructing our humanity with its shadows and light, but she also examines the new constructions and formation of identity on the European continent, on the basis of memory, forgetting, and reminiscences. This Africa, which provides a fresh view from afar, has some words to say as well about the construction of Africa currently under way. This other Africa has seen the rest of the world and knows what we must and can share with the rest of the world, and in turn, in what ways the rest of the world can inspire us.

Fashion and design are two of the areas of artistic expression where the genius and creativity of African artists working with forms is most on display. This brilliance is best expressed through the artists' aptitudes for recycling, synthesis, and revamping.

Without public fanfare, these artists and designers have resolved the question of cultural synthesis through the very harmony found within it. Their work is a mixture of inspiration derived from local styles and forms plucked from elsewhere. The works of Alphadi and of Selly Raby Kane—one through a classic vein, the other through a resolutely futuristic one—bear witness to this capacity of remix culture that they seemingly are playing off and in competition with the musicians of the continent. Africanity is a movement that no single predecessor can once and for all take into account and summarize or define. It is syncretic, and its lone task is to produce that which is functional and beautiful.

Afrotopos is this space of the possible that has not yet been realized, but where nothing insurmountable will prevent it from coming into existence. There is indeed a continuity between the real and the possible. All it takes is knowing how to properly uncover the latter, to think and work for the conditions of its realization by removing what hinders it. Limits are always mental. The first step is to imagine that the world upon which we act contains a larger number of possibles than the real allows us to glimpse.

The world is always ripe for new creations and improvements. There is a renewed genesis for all things. The eternal incompleteness of forms requires their constant reinvention. Here the poetry of Césaire[2] is a precious resource. It invites us to remember to never consider the work of humankind as finished; it reminds us to inhabit the vastness of thought and not merely confine ourselves to the smallest corner of our ideas, to carry the last drop of saved water to one of the most distant branches of the sun, to belated burned-out islands and sleeping volcanoes . . .

African Cities

Configurations of Possibles

The city is a human oeuvre par excellence. It is a space for the deployment and concatenation of social and individual life: a site where a significant portion of the population comes together. A configured space, so that life's necessities for living together—security, education, the economy, and pathways for communication, all the diverse activities required in community life—can be properly articulated for the benefit of the city's inhabitants. The city's most practical aspect consists of organizing to the best of its abilities the concentration of activities necessary for social life. A city is nevertheless not merely something functional but a site for a collective adventure oriented toward social, political, and cultural ends. And within the site of the city we see the idea of making a body out of it.[1]

At the end of the second decade of the twenty-first century, approximately 471 million people, over 45 percent of the African population, reside in cities. By 2030 the population of Lagos is estimated to be 25 million inhabitants. Kinshasa's population is expected to increase to 16 million people. The city of Cairo will have a population of 14 million. And the population of Dakar will be around 5 million people. Africa is becoming urbanized at a much faster pace than any other continent in the world. As a

1. The social body is more than the sum of the individuals it is composed of; it is derived from a common project of living together, a political project that goes beyond simple functional concerns. One could even say that a city is a project of the edification of the ideal city.

result, the continent is beginning to encounter a number of spatial, environmental, demographic, and security challenges. Taking all of these challenges into account requires a great amount of urban planning, space management, water management, energy and waste management, as well as essential communication pathways . . .

There are a variety of ways for reading the cityscape. There is the technical reading (what we call urbanism or city planning). We also have the social and symbolic reading of the cityscape. The city can be thought of just as much as a site[2] or a territory[3] as it can be thought of as an organic totality or circularity. The city is a living body engaged in a process of growth and metamorphosis. African cities are territories whose configurations are changing. Social, cultural, and demographic reconfigurations are currently under way. These various dynamisms contained within the city are directly linked to the worldviews of the people who not only live in the cities but also *inhabit* them.

Here, it has less to do with thinking of the city as a superstructure (which it certainly is) than as a production of meaning or direction [*sens*] whose significations inform our social and political reality but, above all, our imaginaries and our projections.

Flâneries within African Cities

During certain visits to various African cities and observing their appearance and rhythms, tendencies of urbanization, and their atmosphere, the same feeling constantly rose up from within me that they were all searching for a face, that they hadn't yet exactly found their own true identity, that they were being tossed about by the winds, subjected to the dynamisms of a certain form or a

2. A site is a space where elements are distributed in a relation with coexistence. This relation is often static, and the configuration of positions is somewhat rigid.

3. A territory can be defined by the collection of movements that are deployed into possibilities. It's a space of circulation.

certain desire of modernity, caught between a bygone past and a future whose enigmas were yet to be deciphered.

There are certain cities that immediately come into existence as a ready-made whole. This is often the case with the newest of cities, such as Dubai. There are also cities that appear as if they exist standing up, as Céline claimed was the case with New York City. There are also cities that are "flat and spread out, cities stumbling over their own common sense, inert, breathless, and out of sync with their own flora and fauna," as Aimé Césaire would say about Fort-de-France. But there are also palimpsest cities, at the heart of which several movements, several layers, several strata are superimposed and combined to form a sediment of the cityscape. This is the characteristic trait that I see shared the most by all African cities. The overall impression that one retains from passing through them, despite each city's unique diversity, is first and foremost a sense of the city's simultaneous intensity and density: a circulating energy, an overflowing vitality, a dynamism and buzzing creativity, but along with this energy, one also is confronted with the a feeling of chaos, of congestion, narrowness, and a subsequent sense of suffocation. One gets a sense of a certain indecision with regard to the future forms of the city to come, and oftentimes an incongruity, of a contemporaneity of several worlds; one often can glimpse several different eras mixing together, with a variety of architectural styles bumping up against each other, along with a variety of ways for inhabiting the public space, between the cityscape and the countryside, between bricks and water jugs . . .

In the city of Bobo-Dioulasso, the red earth and the dampness of winter immediately grab hold of you. The buzzing Zémédjan taxis, the ambiance of the bars, marketplaces, and large boulevards all evoke a future city under construction. Impressions of an austere Faso that is sprouting and silently growing. Kigali, on the other hand, is a very well organized and clean city whose green expanses are carefully looked after and well kept. One sees the citizens of the city respecting the norms with carefully demarcated

construction sites alongside revamped public spaces. A law has been enacted prohibiting merchants from installing their wares on the sidewalks. Even the highways lack color and noise, and a noticeable rigor of order reigns. The speed limit is set at 80 kilometers per hour on the hills, and the natural landscape is majestic. Nevertheless, the city seems to be lacking just a bit of craziness, a slight touch of the unpredictable.

With the paint peeling off its buildings, the white elegance of Algiers evokes another time. Taxis that never seem to stop, large avenues full of public structures leading you down to the corner of a medina, into a traditional market, a souk, as if entering into another city, into another time, with a Mediterranean sea whose piercing blue eyes stare into the inner depths of your heart.

From out of the powdered sands, the majestic doors entering into Bamako open as if onto a city from antiquity. One encounters wide and long avenues, the Sudano-Sahelian architecture of its buildings, the numerous bridges one must cross overlooking the rivers below, neighborhoods with evocative names such as Hamdallaye, Djicoroni. As for Nouakchott, one discovers a city that's "flat and spread out," less dense, open and airy, and giving way to the bright gleam of a sea of sand as a result of opening out onto its deserts and its ergs. Proud and sumptuous, Abidjan is the lagoonal city, largely endowed with infrastructure; its urbanization was thought out as a whole and is largely devoid of any remnants or stigmatisms from political conflict, but the city is still being reborn by great leaps and bounds.

Nestled on the Atlantic Ocean, the city of Dakar is tumultuous and whirling. It's the very prototype of a palimpsest city. Several layers comprise the mingled sediment of the cityscape so as to furnish it with its current face. Its colonial history is blended together along with its semi-legendary and semi-mythic history. Dakar is a city in movement that is constantly in the midst of creating itself. Almost suffocating, it seemingly has lost its lungs despite

its proximity to the Atlantic Ocean, and green spaces are very rare. Dakar functions as a city understood as a perpetual construction site where international immigrants (from Italy, the United States, and France) have become the creators of new neighborhoods, adding their own idiosyncratic aesthetic to the city and populating the city with new creative styles. The social, economic, and demographic dynamics have become superimposed, and we are producing an unplanned, undreamed-of city that is growing in an anarchical manner.

Dream City: Space for the Projection of Desire

The singer Johnny Pacheco prophesied that by the year 2000, Dakar would be like Paris. Which is clearly not the case, and that is a good thing. The imperative of the African continent is to rediscover its own rhythm and movement. It's not about reproducing pale copies of Berlin, Paris, or New York. Nor should Luanda, Lagos, or Nairobi resemble Dubai, Singapore, or Shanghai. Our cities must resemble us and express the form of living together that we have chosen (which presupposes we have already deeply reflected on and resolved the question of who we are and who we want to be). The singular mode of being in the world that defines our identities must be reflected in the appearance of our cities. The inscription of particular modalities of existence within space is the work of architects, whose greatness is to conceive and bring into existence these complex forms.

Beyond simply taking charge of the necessary functional aspects of the city, we must also undertake an aesthetic, social, and philosophical reflection concerning our cities. Our African architects should be the builders of the Sahel, of the desert, of the mountains, of the tree-filled savanna. Their art takes on its larger sense when it is connected with the culture, society, climate, and the human and physical geography of the sites it invests in. During these current times, when environmental concerns are continuing to be placed at

the forefront of everyone's minds, we can also reflect on the notion of an "integrative" city that seeks to greatly reduce its overall consumption of resources while also being respectful of the environment. We must reacquaint ourselves with the benefits of nature already at hand: making use of solar energy to illuminate spaces and heat water, using bioclimatic materials for construction, and tilting or making the walls incline during the dry season in order to let tradewinds pass through to refresh the city's body. To take up such a historic initiative is to first and foremost build African cities based around models that reflect its singularities and worldviews.

Before being a city, a cityscape is a space for the deployment of individual life. And in this light, within the interior management of our dwellings, our architects must take into account the way in which we live (our way of life is largely linked to our various cultures), so that, in the end, we can fully deploy ourselves as beings.

We must allow for the city to be the very expression of the civilization we aspire to build, in letting the stones and the colors of the buildings speak, by demarcating closed and open spaces, by appealing to the language of lines and forms: the horizontal line can evoke depth, the open sea, and the distant; the vertical design and the lines that shoot off into infinity can indicate our aspirations for elevation. Of course, we need individual as well as social sites, but we also need spaces that shelter and help one's spirit grow. In our cities and dwellings we must plan sites that help us gain and retain a sense of being part of a larger community, for this sort of intimacy helps us to feel the essential vibration of our being in the world. These spaces are in need of pure forms—sometimes forms that are geometrical and abstract, sometimes more complex and entangled—in order to represent the lineaments of the paths that ensure growth.

We need memorial sites, for remembrance, museums, experiences created by African designers that will give life to our lived history and how we have envisioned it. But we also need cultural

sites, sites of conviviality, gathering places, where we can come together as a community. The dream city, an African prospective of the city, could resemble the work of the Ghanaian architect Kobina Banning, who imagined a Sankofa Garden City Park in the middle of Kumasi, the second-largest city of Ghana, where you could truly get a taste of the ultimate African urban experience: an amphi-theater, stands for merchants, networks of urban transportation, primary healthcare centers, parks and gardens full of indigenous plants, spaces for meditation and prayer . . .

Despite only being virtual, this construction is largely anchored in Ghanaian culture. Before dreaming it up, Banning spent several months observing the ways in which the 3.6 million inhabitants of the former capital of the ancient Ashanti Kingdom occupied their urban space. "During another era, Kumasi was known as the gar-den city, and his project was to reappropriate informal traditional spaces as starting points for examining the city's future." The term *sankofa* is at the heart of his concept: "Nourish oneself off of the past in order to better move forward." In contrast to those who see nothing but chaos and disorder within African cities, Banning is persuaded that each city functions in its own particular way, an "ingenious and organized chaos" that he first wanted to grasp so that he could then project it into the future.

To create a body using the notions of fluidity and transience. To make use of the idea of impermanence so as to align it with the possibility of new reconfigurations; to make use of objects in different ways than they were initially created for. To grasp the idiosyncratic functioning of the city, its organized and ingenious chaos, to understand the city's various logics and significations, and to articulate all of this in the most efficient way. And, within all the various construction sites of our cities, we must leave room for creative spaces: unfinished sites that represent the possibles . . .

Building cities that don't simply desire to scrape the sky, not because they lack the required ambition for such a task but because

their inhabitants choose to privilege these other interstices where we can encounter each other, where we live and where we do so fully. Here, the construction begins by way of destruction: a destruction of mimicry and a bypassing of oneself.

Self-Presence

The True Increment

The conditions of the true increment—for truly taking measure of oneself and for a real creative transformation to unfold—first begin by way of putting down some roots in order to make oneself older and, as a result, newer. By way of this relation, through a reconciliation with the multiple sources of one's identity, what then becomes of the utmost urgency is a process of selection, of memory work, a work of history, but also an activity of dusting oneself off. Such a practice cannot be undertaken without a rearticulation of the relation one has with oneself, troubled by so many centuries of alienation. It becomes a question of being capable of thinking oneself anew as one's own center. A fundamental rupture emerges that requires some amount of self-repair in the form of the discourses that Africans produce in regard to themselves and in regard to their choice of principal addressee. The affirmation of a culture, of a civilization on the same foundational bases as its negation—that is, race and territory—was no doubt necessary during a certain era. The anticolonialist political and cultural movements, such as Négritude, were spaces of struggle against racism and colonialism through the affirmation of the dignity of the African man as a producer of culture and civilization, in a world that denied his place, largely underestimating his cultures, or attempted to enclose him within a radical alterity at the edges of common humanity. These anticolonialist movements fulfilled their historical missions.[1]

1. In spite of the criticisms we can pose against it, most notably the use of

Today it's the terms of the debate themselves that need to be tossed aside. We no longer need to craft responses to centuries-old questions posited within narrow frameworks. We no longer need to respond to these repetitive questions that appear to come from some bygone era. Quite simply, we no longer need to justify ourselves.[2] We no longer need to respond to myriad injunctions: to articulate an African proposition of civilization, outside of a dialectic of reaction and affirmation, through a creative mode. To affirm a presence in the world through the free mode of self-presence: to be with the greatest of intensities, to express oneself, and to propose to the world one's own *élan vital*.

In order to enrich global thought, we are told to heed a variety of whispers: we must play the game of becoming, of exchange and reciprocity, so as to avoid the enclosure of identity and the illusion of permanence. We must accept our hybridity and cultivate the reflexivity of our situations. *Métissage*, hybridity, creolity, certainly. We know, however, that there is no such thing as a pure civilization and that all civilizations are hybrid. The hybridity of civilizations is not something that is derivative. It is original. Hybridity is at the beginning of the process of the elaboration and compression of elements that make up a totality. The intelligence of a civilization

colonial anthropological categories in order to defend its position and its production of a discourse about Africa that was the inverted double of the West, Négritude constituted a necessary response and needed to be articulated at that time period.

2. Each time there is a cultural proposition that wants to claim itself as being African, we stir up the specter of essentialism or that of the continent's cultural diversity in order to keep Africa from staking a claim on its own name. And yet, when one evokes Asia or Europe or America as having unique and specific cultural qualities, no one finds anything wrong with this claim. We easily and readily admit the existence of an Asian culture, a Chinese culture, or a European philosophy or a German philosophy. And in this case, no one questions what the specificity of each culture is that makes it German, Chinese, or Asian. There is no polemic based on the fact that all these aforementioned cultures are in a constant state of change while also simultaneously being in the midst of reconsidering larger notions of the specificity and plurality of their unique cultures.

resides in its capacity to form a synthesis of the complementary worlds that offer themselves up to it so as to integrate them into a *telos*. For Africa, it's precisely this *telos* that must be thought and defined. What is Africa's project for itself and for humanity?

Following this same perspective, Africa must also choose to color its hybridity. This requires choosing the dominant tint (since it has proven to be the best for Africa's project of humanity) of its mixture of colors. Under the pretext of Africa's creolization, it will not be a question of forgoing the choice of a specific color but rather of constructing the voice for all of Africa's men and women. Every true *presence* is first of all a self-presence.

We are the result of what has persisted from the syntheses that have been applied and performed on us. As such, for us Africans it's also a question of learning to get to know ourselves anew in starting over, of proposing new answers to the question of knowing who we are. However, more than simply reflecting on who we are, we must also consider what we want to be, what we want for ourselves and for the world. All of these primordial questions will comprise the object of our concerted reflection. It is only after this work has been completed that a presence with others, in the form or mode of fraternity, can be achieved, for there is no true dialogue outside of the existence of a truly singular voice, recognized as such, and which is posed within a true relation of interlocution. There is no possible dialogue within the incessant ever-changing inherent potential for an atonality of one's own voice: hence the necessity for always renewing this dialogue of interlocution, fine-tuning it, and making one's voice intelligible and audible within the shared dialogue of the collective. Africa's sole condition is precisely this completed construction of a veritable interlocution whereby, to refer back to the empowering words of Alioune Diop, "Africa's presence in the world will have as one of is effects to help increase the profundity and maturity of human consciousness," the only objective worthy of being assigned to it.

The Lessons of Daybreak

As the sun rises over the life of humanity and the forward movement of societies, a new day begins. An uncertain light grows and progressively illuminates the paths of the walkers at daybreak. Throughout the daytime hours, this light will shine brightly over various works in progress and their obstacles. This time of the half-light is also the time of the breakthrough, and those who take part in it need nothing more than a small, weak shimmer of light to embark on the voyage: they are the intermediaries. These beings are fully aware of the necessary steps to continue their ongoing march of progress: that the stones they shape are fundamental for the stability of the future buildings to come, whose completion they perhaps might not even get a chance to see. They are also well aware of the fact that, within this present moment, they must be up to the task of the necessary requirements for helping to realize the world they wish to see come into existence. One of these requirements is the capacity for discerning the extraordinary from the impossible and then setting about accomplishing it. This is what Mandela did in a subjugated South Africa through the creation of a philosophical code and ethics derived from the Xhosa culture: the philosophy of Ubuntu. It's precisely within a present moment replete with delicate opportunities, ripe with multiple potentialities, that the African continent is situated. Always overflowing reality, the real foreshadows a number of possibles that only require the ardor of faith and labor in order to arrive into phenomenal time.

Africa no longer needs to try to catch up with the rest of the world. It no longer needs to run on the same paths the world

indicates for it, but rather to deftly walk the path it will have chosen for itself. Africa's status as the oldest child of humanity means that it bears a great responsibility. It must be prudent and extract itself from following the irresponsible path of globalization that could endanger the social and natural living conditions for all of human life. Quite simply, Africa must refrain from taking part in the childish competitions and rivalries between nations who carefully eye each other as competitors in order to see who has accumulated the most resources and wealth, the most technological gadgets, the strongest sensations, the largest capacity for the *jouissance* and enjoyment of goods and the pleasures of this world.

Africa must break free from this age of immaturity where nations only compare or identify with each other and what each country can provide for the rest of humanity by way of questions concerning only their yearly GDP and their produced wealth or even on production extracted simply by means of predation and where a nation's worth is viewed through its place in the classification of ranking systems in Ali Baba's cave. Africa's lone urgency is to have confidence in itself and firmly embrace the potentialities it already possesses and to fully actualize them in all areas, first of all for itself, and then for the rest of the world. Africa must complete its decolonization by way of a fruitful encounter with itself. It must turn inward—toward its inner self—in order to fully come alive again. Within the next thirty-five years, Africa's population will represent a quarter of humanity. It will be the vital force of humanity: the largest proportion of the population between the ages of fifteen and forty-five will be African. A demographic weight and a vitality that will tilt the social, political, economic, and cultural balance of the planet. And in order for Africa to be a positive driving force, to help steer the current course of things in a much more affirmative direction so as to uplift humanity,[1] it will take a profound cultural revolution. This cultural revolution will

1. Mbembé, *Sortir de la grande nuit,* 55.

begin by changing the way Africa sees itself, by restoring its own self-image when it gazes into the mirror, respecting itself, reevaluating itself in a new light, and by healing itself from all of its traumas through once again rediscovering Africa's large capacity for resilience. Africa must stand up, all by itself, on its own two legs. And for this to happen, Africa must respond to the demands of its demography by nourishing its populations, educating them, assuring them of the proper conditions—as much individual as collective—for a life worthy of peace, security, and freedom. But it's not simply a question of responding to the biological and physiological needs of its children. Above all, Africa must participate in the work of the edification of humanity by building a more responsible civilization, one more concerned about the environment, about a harmony and balance between different orders, of the generations to come, of the common good, and of human dignity: Africa must once again become a poetic civilization. To edify a human being is of course to heal him, to clothe him, to feed him and educate him. But above all, it's about fostering the growth of the individual so he can become fully whole, so as to bear witness to the flourishing of the most brilliant aspects of his abilities. And it's in this way that Africa will help contribute in elevating humanity to another stage.

And for this to occur, Africa must choose.

Africa must choose its own economic model. Growth is an objective to the extent that it helps one to respond in an adequate manner to the needs of one's populations. However, these needs are not limitless. Desires can be limitless; moreover, our current era produces an infinite number of them. The qualitative improvement of the social body being the principal goal, one must be prudent in choosing the type of growth to set into action, for these economic models are not neutral. Some of these models only deepen the inequalities already in place and further impoverish those who already find themselves in a diminished state. Other economic

models have a strong ecological imprint, and still others bene-
fit specific social groups constituted by certain lobbying groups.
Infinite economic growth within a finite world is a myth. Western
countries are already experiencing these limits. They should learn
to build and partake in a prosperity without growth. It will also
be a question of changing the end goal, the structure and cadence
of economic growth, in putting to work models of creation and
wealth distribution based on the specific needs of populations,
and not on the growth of the market. As a result, we must choose
the type of industrialization we want to set into motion and reso-
lutely opt for a model that will not be based on fossil fuels. We must
learn from the mistakes of the industrial adventures of the past
several centuries. Accepting the task of becoming the continent
whose industrial activity has the least impact on the environment[2]
provides us with the opportunity to learn from the bad habits of
other regions and choose different paths than theirs, since these
less destructive paths do exist. The African continent must also
have a more acute environmental awareness, all the more so con-
sidering that the continent is already experiencing, and proactively
dealing with, the effects of climate change and the reduction of
biodiversity. The large availability of natural resources on African
soil, as well as sources of renewable energies, means we can choose
more responsible modes of production.

And since the world is once again turning its attention toward
Africa's resources—coveting them and pandering to it in order to
continue the maddening direction of globalization—Africa has the
opportunity to impose a civilizational shift by refusing to perpet-
uate these models of production and accumulation of wealth. By
shutting off the fifth engine, Africa has time to decide the destina-
tion of the locomotive. A civilization is not only based on material

2. The African continent represents 4.5 percent of greenhouse gas emis-
sions.

and technical values; it is complemented by the moral (and aesthetic) values that orient it. We must rethink our conception of progress.

Africa's own conceptions of politics. Africa's own modes of the organization of power. Africa's own conception of citizenship. Africa has the choice of enlarging them and of once again wedding the fluidity of the notions of belonging derived from its diverse cultures. Africa is not obligated to hold on to the notion that a nation must remain confined to a specific territory, nor to the notion that an individual's identity must be solely defined by race or ethnicity. If it wants to, Africa can redraw the borders created in 1886. It must be innovative in its deliberate models and intelligently choose among the options that are offered.

Africa must rethink the roles of its various cultures. Culture should be an affirmative cultivation: cultivating meaningful reasons to live. It is an active process of setting one's sights on goals and the chosen direction for the human adventure. For this to happen, there must be a radical critique within Africa's cultures so as to question any part that reduces humanity, diminishes it, limits it, or degrades it. But we must also rehabilitate those cultural values such as *jom* (dignity), of living together, of *téraanga* (hospitality, mutuality), of *kersa* (modesty and humility), of *ngor* (a sense of honor), in order to exhume and revive the profound humanism of these cultures. Such is the profound cultural revolution that the African continent must undertake and set into motion. And it would seem that the future of humanity is on Africa's side.

From this day forward, as in the time of the first rising suns, Africa will once again become the spiritual lungs of the world.